# Art

## as a Hidden Message

### A GUIDE TO SELF-REALIZATION

# Art as a Hidden Message

## A GUIDE TO SELF-REALIZATION

BY J. DONALD WALTERS

CRYSTAL CLARITY, PUBLISHERS

Original photography by J. Donald Walters
Cover and book design by Christine Starner Schuppe

Printed in the United States of America

ISBN: 1-56589-741-2
1 3 5 7 9 8 6 4 2

Crystal

Clarity

Crystal Clarity, Publishers
14618 Tyler-Foote Road
Nevada City, CA 95959
800-424-1055
http://www.consciousnet.com/CrystalClarity

# Preface

by Derek Bell

*(World-renowned harpist of the five-time Grammy–Award winning group, The Chieftains, Ireland's best-known interpreters of traditional Celtic music, and one of the Emerald Isle's foremost contemporary musicians.)*

*25th of July, 1997*

I have known J. Donald Walters in several contexts for many years. First, I've known him as a gifted, and I will even say inspired, composer. I recorded *The Mystic Harp*, an album of his most poetic musical compositions, in 1995.

What strikes me above all about Donald is the all-embracing nature of his mind, which is probably the result of his incredible capacity for concentration. He has an ability to uncover countless unusual aspects of a subject, and to reveal them in an unexpected and original light. When he turns the spotlight of his concentration on any given subject, he leaves no aspect of it uncovered.

I have also known Donald for many years as one of the few still-living direct, full-time disciples of the great Paramhansa Yogananda, author of the now famous *Autobiography of a Yogi*. I myself consider that Yogananda was one of the most important beings to incarnate on this planet in many centuries. I've been familiar with his work since 1962, and have been

aware of Donald, as his disciple, for most of that time.

It was not until about 1989, however, that I spotted Donald's masterly autobiography, *The Path*, in a London bookshop. After reading it, I decided at last to get in touch with him. We corresponded, and I subsequently read a fair cross-section of his books, heard some of his tapes, and watched a few of his videos. I also visited Ananda several times, the beautiful village Walters himself founded in 1968. There I learned from him and his followers as much about Yogananda as I could. In 1995 I offered to record some of Walters's music, both because I loved it, and for the sake of completeness—of returning with gratitude what I had gained.

In Donald's books it has become obvious to me that he asked his master, Yogananda, more interesting questions than anyone else, and that Yogananda, consequently, gave out many of his most interesting ideas to this disciple. The exchange between them has become, subsequently, a gift to us all! Another thing has become obvious to me in reading Donald's writings, and that is his unbiased discrimination. Unfailingly, he makes it crystal clear, for example, as to when, on any given subject, he is expressing his own ideas and when he is stating what Yogananda said. Such perfect fairness is, I believe, not at all usual.

What we have in J. Donald Walters as an author, then, is an unusual and powerfully magnetic mind, and also one whose judgment is always fair. To me, *Art as a Hidden Message* is by far the most important book of its kind since the publication of that work by the great impressionist English composer Cyril

Scott, *Music—Its Secret Influence Through the Ages.* Donald's work is, however, more comprehensive, for while Scott's is largely concerned only with inspiration through music, Donald's masterpiece covers all the arts: painting, sculpture, architecture—even dance, photography, film, and the theater. An important point strikes me in the works of both writers: Neither of them believes in that tired and fortunately fading doctrine, "art for art's sake." Both are convinced that Art holds a potential for both purpose and meaning. Scott and Walters both emphasize also Art's potentials for healing, for effecting beneficial changes in people's lives, and even for changing and uplifting the environment.

Donald refers to the general, lamentable, ignorance in these matters in the West, but does not dwell on it. From his amusing Prefatory Note on the masculine pronoun (now there's a vexed question!) to his grand finale, the last chapter titled "Where Is Art Headed?"—from beginning to end, in short—I found this book completely enthralling. To have covered so many aspects of the subject so thoroughly, and in so few pages, is in itself an amazing accomplishment. Just to run the eye down over the chapter headings in the Table of Contents gives an exciting preview of the erudition and of the sheer range covered in this mighty opus.

Anecdotes and examples abound. From the description of what deserves to go down in song and legend as The Painted Pipes of Kauai, to his stories of Handel and Mozart and of an ancient Indian manuscript foretelling the lives of many people living today, to illustrations from Shakespeare, da Vinci, Coleridge, P.G. Wodehouse, and many others,

to his most interesting comments for and against formal study, and his arguments on the need for balancing reason with feeling, this book makes for altogether fascinating reading.

Donald's predictions for Art's future, also, are enlightening. They include a return to simplicity, and a renascence of beautiful melodies. I cannot but add that I, personally, would deeply regret the fulfillment of one of his predictions: the eventual disappearance of the symphony orchestra. For I love symphony music—as does Donald, for that matter—with its grandiose but also extremely subtle nuances of expression. To me, the symphony orchestra is like a great, living organ, and it is my own favorite medium of composition. But honesty obliges me to add, sadly, that Donald's prediction is already coming true.

I was greatly intrigued by his idea, expressed in the last chapter, that printed notes would again become more "skeletal," as they were during baroque times with the figured bass, and as they are today in jazz, pop, and rock music. I applaud Donald's prediction of greater cooperation between composer and performers, though at the same time I worry that such cooperation might get taken too far, and thereby destroy the composer's original intentions!

I salute Donald, in conclusion, for what I consider a true masterpiece. *Art as a Hidden Message* is a monumental work, and should be required reading for everyone. Artists, especially, will benefit from it, and should carefully read, study, and act on what is enshrined in these pages. This book is, I believe, the most important book of our time on this vitally

important subject. May it be well received, and have far-reaching success in refining the way people approach a subject so crucial to the emotional and spiritual health of society.

Derek Bell
Bangor, Ireland

# Prefatory Note

My reference to art in this book is to all the arts, and not only to painting and sculpture. Schubert's song in praise of music begins with the words, "Thou glorious art! *(Du holde kunst!)*" It is in this spirit that I use the word, "art," here. My reference is to any esthetic medium that can carry the mind beyond the mechanics of mere craftsmanship to the experience of inner feelings and higher states of consciousness.

In response to a previous book of mine, in which I expressed some of these ideas, Steven Halpern (the well-known New Age musician and composer) wrote me to say that while he liked my concepts, he took exception to my consistent use of the masculine pronoun. On principle, I agreed with him, and tried to follow his suggestion in the writing of this book. For I hold no bias on this issue. Certainly, greatness in the arts transcends sexual differences. Moreover, you will see as you read these pages that I emphasize the importance to clear understanding of the feeling quality, and the importance of art to the development of our feeling faculty. Women, more often than men, understand the importance of feeling—especially of intuitive feeling.

But every time I tried to adhere to the modern convention of writing "he or she" and "his or her" in reference to the individual, I found it cumbersome. And I realized anew why, in many languages, including English, the masculine pronoun does double duty, serving also as the impersonal

pronoun. The word, "it," obviously won't do in reference to men and women. "They" is sometimes used, but this practice is clumsy and ungrammatical even when penned (as it was) by such a fine writer as Jane Austen. What would settle the debate would be, of course, some humanized version of the word, "it." *"Ini,"* for example, accomplishes this purpose well in Bengali.

Until the arrival of some such solution in the English language, however, I simply refuse to think "pants" and "skirts" when what I'm talking about is the human being, stripped of sexual considerations.

Please, then, dear Reader, understand from the outset that my use of the masculine pronoun embraces *both* men and women. The question, for me, is simply one of style. If and when our English language produces an impersonal human pronoun, I'll be happy to use it. Meanwhile, my use of "he," "him," and "his" refers not specifically to the male of our species, but simply and sincerely to the individual.

J. Donald Walters
Assisi, Italy

# Contents

# Introduction

When you look at a lake, what do you notice?—the broad expanse of water? the ripples on the surface? the beaches and trees? the people boating, fishing, or swimming?

A biologist examining the same water under a microscope sees something altogether different: a teeming world of microbes, invisible to the naked eye. And if a physicist submits the same water to scientific analysis, his focus will be even more minute. He will speak of shining electrons and whirling atoms: miniature planetary systems, surrounded by as much space, relatively speaking, as the empty reaches of our galaxy.

There are many ways of viewing any subject. The broad view is often scoffed at by specialists, to whom it seems too imprecise. Broad statements on the arts face the same criticism. Indeed, a broad view of art demands that one soar high above the twisted jungle of "isms." To this view, the various schools of art emphasize matters of merely passing interest. What count, here, are the far-ranging concepts on which art rests. Indeed, the broad view demands that one transcend art itself and view it in the general context of humankind.

For art is an expression of human nature. It touches on human values, and cannot really be understood independently of those values.

The close view obviously has its place also. Many artists, however, never ask themselves whether their art bears any meaningful relation to such broad

questions as moral, spiritual, or merely human values. Writers often become so enamored of the well-turned phrase that they may take offense if anyone asks them whether, apart from being clever, their *bon mot* is also true. Violinists frequently become so engrossed in technique that they forget to ask themselves whether the music they are playing is inspiring. And many painters become so beguiled by subtle differences of color and intricate complexities of design that they listen with impatience to any suggestion that color and design might serve some purpose deeper and more subtle than sensory stimulation.

People devote so much energy to minor artistic arguments that they allow themselves to be distracted from the greater themes. Solemnly they debate impressionism, postimpressionism, realism, surrealism, cubism, conceptualism, modernism—an endless array, its very interminability suggesting the conclusion that no "ism" will ever be the last word, artistically.

Consider, again, the heat that was generated by the futile controversy concerning the "real" authorship of Shakespeare's plays.

People who immerse themselves in issues such as these develop almost a language of their own, one as esoteric as any system of theology. Their arcane judgments seem designed purposely to exclude the uninitiated. They speak matter-of-factly of the "tension" between an artist's "conceptual approach to construction and the associational power of the objects he assembles" (a direct quote, by the way, from an art review that appeared a few years ago in

a national magazine). Perhaps they do not even want to be understood.

It is time we stepped back a little from all the "isms," and rethought what it is that the arts might express for us all, as human beings.

This, then, is the purpose of this book. It is to give an overview: to concentrate on the lake, and on the needs of the people who visit the lake, rather than on the minutiae of the water particles. My purpose is to reach beyond passing trends in art and see whether, in an overview, there may not be found a guideline to life's true purpose and meaning.

# The Arts as Communication

In the center of a complex of little shops on the island of Kauai, a configuration of huge painted pipes twists its way upward within the framework of a wooden tower. The pipes are prevented from further upward growth, not by any logic of esthetics, but simply by the presence of a platform at the top. They look like some complicated sewage system, or perhaps like the water supply for a suburban housing development. In any case, it is clear that they are too massive to serve the little complex of boutiques and souvenir shops that huddle around their base, and over which they loom like some medieval dragon awaiting its daily maiden so that it can get on with its dinner.

I endured the sight for two or three visits to the island. Finally I asked one of the shop owners, "When are they planning to cover those pipes?"

"Cover them!" he cried indignantly. "Why, that's sculpture!"

"You mean—they actually serve no practical function?"

"That's right," the island patriot replied proudly, his tone implying, "You see? We got everything here! Culture, too."

Okay—okay. But to me even so, those pipes are— well, to put it delicately—unlovely. Their size is

disproportionate to the little, box-like shops over which they brood. They are completely inappropriate to what one must assume to be the natural theme of such a shopping complex. In fact, they seem perfectly pointless.

The real issue at stake here, however, is not whether this particular product of an artist's lunatic fancy is really as ugly, inappropriate, and meaningless as it appears. Rather, the issue is whether I have any right to pass my own judgment on it.

I may be within bounds in calling those pipes ugly. Many people, however, would say that I had overstepped my limits even here. For to call them ugly is to imply they ought to be something else. The artist may have actually *wanted* to express ugliness. Maybe ugliness, for some private reason, was the statement he intended. If so, is it my place to tell him he *shouldn't* make such a statement? Perhaps not. In this case, however, I must add that the souvenir vendors might be wise to consider whether the artist was not, just possibly, holding up their pretty little displays to ridicule.

When I go on to suggest that heavy pipes, amid all those flowered shirts and picture post cards, lack a certain appropriateness, there are many who would tell me that I am pitting my purely personal taste against that of the creator of this great—or at least massive—opus. Again, what right have I to do that? None, perhaps. Certainly not, in fact, if the artist's commentary was deliberate—though I doubt that it was. Anyone subtle enough to intrude satire into this twist of plumbing would have been clever enough also to be more artful about it.

No, I'm afraid I am able to see no higher purpose in this work. It serves as a satire of itself.

But it is when I call the work meaningless that I really demonstrate myself capable of almost any crime.

"Why *should* a work of art have meaning?" (I can imagine the outraged demand.) And: "Why do you want it to make a statement? Why can't it just be itself?"

Well, I didn't say its statement had to be something one could put into words. Many great works of art contain no explicit message. Consider the Mona Lisa. Even though that painting makes no open statement, it says something beautiful to me, and to enough other people besides, for it to have been ranked among the greatest paintings of all time. Nobody has ever accused Leonardo of having created something meaningless, even though his admirers have been trying, unsuccessfully, for centuries to decipher the Mona's mysterious smile.

I call a work meaningless if it not only says nothing to me, but seems incapable of saying anything to anyone else, either. Sometimes I am mistaken in my judgment. (We all have our blind spots, after all. Even our own tastes vary from time to time.) The point here is: Where does the artist's personal statement end, and the public's right to understand it begin?

It should be self-evident that if a work of art is put on public display, the public ought not to have to shrug it off as the artist's personal secret. His work should represent at least an effort on his part to communicate *something* to *someone*.

21

I don't mean he has no right to protect his privacy. Although personal experience has probably been the inspiration for most great works of art, there are aspects to every such experience that can never be shared if only because they are too particular to the artist's own life and circumstances. These aspects ought either to remain personal and be kept from public scrutiny, or else translated into terms that others can relate to their own lives.

I've learned the importance of such "translation" when answering questions after a lecture. If anyone's question concerns some matter that is too particular to his own case, I try to universalize my reply so that others in the audience will be able to relate to it also.

The English poet W. H. Auden, on the other hand, limited the audience for some of his poems so drastically that, in my opinion, he kept his own stature to that of a minor poet. I once asked a friend of his for help in understanding a poem titled, "Letter to a Wound." The friend replied, "It's about something so personal that only two or three of his closest friends know what it means, and they've promised not to reveal his secret to anyone." I ask you, is it fair to offer a work of art for our inspection with the deliberate intention of leaving us baffled?

Even our most intimate joys and griefs contain some aspect that can be shared meaningfully with others. Most people, for example, can participate in the grief of bereavement, provided the experience isn't depicted for them in terms that are too exclusive.

People generally are more interested in their own affairs than in anyone else's. An artist ought to reach out, therefore, and touch them where those interests lie, and not merely impose on them his own

interests. Pointless self-revelation is a sign of immaturity. Works of art that are universally considered great reveal a degree of maturity that we associate with *human,* and not only with artistic, greatness.

You've no doubt heard the grand statement, "Art for art's sake." Jesus Christ spoke pertinently on a similar theme. When people criticized him for healing a sick person on the Sabbath, he replied, "The Sabbath was made for man, and not man for the Sabbath." The arts, too, were made for man, and not man for the arts. "Art for art's sake" is an attempt to justify artistic irrelevancy. What "sake" can art have, that we should honor it? It is man's sake we are talking about in any valid discussion of the arts.

Frank Lloyd Wright, the great architect, insisted that buildings should be responsive to the demands of their environment. Is it possible that a natural environment really demands anything at all—except, perhaps, not to be intruded upon in the first place? When we try to depersonalize art, as people do with the slogan, "Art for art's sake," and as Frank Lloyd Wright did with his attempt to subordinate human demands to those of the environment, all we do is kid ourselves.

Years ago I built a geodesic dome for my home in the woods. My next-door neighbor built a rustic wood cabin. Both the homes revealed an attempt at attunement with our environment, though in very different ways: My neighbor's blended with the trees; mine reflected the over-arching sky. His home suggested the security of living in a surrounding of protective trees. Mine suggested an aspiration to rise above earthly enclosure and embrace infinity. Who shall say which of us better expressed our environment?

From this simple dichotomy of tastes we see that the design of a home cannot but begin with the needs of its owner: with his outlook on the world, and with his philosophy of life.

Art must begin with a personal outlook before it can embrace the impersonal. Without the personal, art is merely *de*personal, and fails even at that because it is impossible for human beings to eliminate human nature completely from their equations. The most abstract equations of physics cannot but filter reality through the understanding of the physicist. The ideal, then, is not to *de*personalize art, but to expand it beyond the personal to the *im*personal. With an impersonal outlook comes a loss of focus on selfishness and egoism, and a growing interest in communicating effectively with others. With a depersonal outlook comes, not deep insight, but a starved and scraggy perception of reality that rather resembles a fowl during a famine.

Every artist must learn for himself how best to achieve a balance between the expression of personal feelings and effective communication. The important point is that there must be a conscious *effort* on his part to communicate his feelings. If he makes no such effort, then the public's time ought not to be wasted in trying to figure out what his art is all about.

If what I have said is true, and if a work of art offered for public consumption ought to represent a sincere effort at communication on the artist's part, then we see removed automatically from the stage an incredible amount of work that has passed for art in modern times. *For if there is one thing that marks whole schools of artistic thought nowadays, it is the belief*

*that communication doesn't really matter.* We might go so far as to add that, if there is one thing that marks a great deal of art in modern times, it is a deliberate attempt on the part of artists to confound their public.

I attended a piano recital a few years ago during which the pianist offered several compositions of his own, along with a selection from a more standard repertoire. I was amazed, listening to his works, to note the lengths to which he had gone to impress his listeners by mystifying them. It was as though he hoped through unpredictability alone to demonstrate his originality and, thereby, his creative genius.

There was no sense of fitness in a single melodic line, chord progression, or rhythmic sequence. Just when the listener expected, and *wanted,* the melody to go in one direction, it would veer off in another as if to say, "Ha! Fooled you, didn't I? See how clever I am?"

Just when a succession of dissonances cried out for resolution in some friendly harmony, disharmonies would scatter off to every point of the compass like an unruly mob. It didn't seem to matter where they went, so long as they left behind them a wasteland of confusion.

Rhythms that succeeded finally, after undisciplined beginnings, in grouping themselves together into some coherent pattern would be ordered peremptorily to "break rank" and stagger about uncertainly again, as if in search of some new, but forever undiscovered, territory.

Obviously, the whole effect was deliberate. Possibly the composer's intention was to educate our musical tastes by shocking us out of our

"bourgeois" expectations. Apart from the intense dissatisfaction each of his pieces awakened in me, however, all I felt was his desire to impress us with musical choices that could not but be, to us, unfathomable. He seemed to be saying, "Lo! Am I not inscrutable? Does not my inscrutability make me wiser than you?"

Artists frequently offer incomprehensibility on a tray of silver—not only to confound their public, but to trick everyone into thinking that their lack of clarity is proof of their profundity. Artistic incomprehensibility is, I think, usually an attempt on the part of the artist to conceal the fact that he has nothing to say.

At no time in any golden age of art has unpredictability been equated with originality. Still less has it been considered a proof of genius. One of the profound satisfactions in listening to a Beethoven symphony, for example, is its perfect fitness. It isn't that Beethoven is boringly predictable, but only that everything he does is so self-evidently *right*. It is what we ourselves might have wanted to do, had we possessed his genius.

I don't mean that for music to be great it must have a familiar ring to it. Sometimes, indeed, an artist—particularly one who is out of step with tradition—will make us work hard to tune in to what he is saying. If he is indeed saying something worthwhile, however, *and if he is clear himself about what he is saying,* people will come to learn his language in time, and to love it.

Normally, the test of greatness in the arts is the ability to state deep feelings and perceptions simply, clearly, and well.

Tolstoy, whose *War and Peace* has been acclaimed the greatest novel ever written, considered the simple folk tales he wrote during his later years more valid artistically than his complex novels. Their artistry lay in their understated simplicity.

Understatement is, indeed, the essence of true art.

A certain famous writer made it a practice to read aloud to his father any new piece that he'd written. His father, though not a literary man, was endowed with down-to-earth common sense.

"I don't understand that passage," he would sometimes object.

"Well, what it means is . . ." and the son would explain.

"Then why didn't you say so?"

The writer claimed that his work was always improved for his father's insistence on clarity and simplicity.

Indeed, it may well be said that until a person can express a thought clearly *and simply,* he hasn't yet fully understood it himself.

It often happens that, when we communicate our feelings and ideas to others, our very effort to do so clarifies them for ourselves. A sincere attempt at communication brings into the open thoughts and impressions that, previously, were not yet completely clear in our own minds. Schoolteachers have often remarked on this phenomenon in their teaching.

Unfortunately, obscurity is the vogue nowadays. The artist feels superior to his public when he can get them to admit that they haven't fathomed him. He feels further sustained in his self-esteem if a handful of esthetes, anxious to demonstrate their

own sophistication, claim to "sense" what he is saying. It is all an ego game, not unlike Hans Christian Andersen's story, "The Emperor's New Clothes."

I remember a man whose habit it was to make obscure remarks, then chuckle significantly at his own wit. I never got the point of those remarks, but assumed that I must simply be missing something.

Then one day I understood what it was he was chuckling about. To my astonishment, it was utterly banal. His other statements, I then realized, must have been equally so. In fact they'd always seemed so, but I'd allowed myself to be hoodwinked by those knowing chuckles.

To offer the fruits of one's inspiration to others, in the form of art, is one of the best ways for removing blocks to clear perception in oneself. This is a final justification for returning to a genre of art that seems almost forgotten nowadays: art that can be cherished, not merely endured.

Unsophisticated humor often says it best. A couple of rustics once visited a modern art gallery and were chuckling at the exhibits before them.

"Say, Zeke," said one, "why did they have to go and hang *that* one?"

"I guess," Zeke replied, "it was 'cause they couldn't find the painter."

Sooner or later, I suspect, someone—perhaps only a little child as in "The Emperor's New Clothes"—will exclaim, "I see now what all the fuss has been about. Those artists were only trying to stir up a bit of excitement. But they haven't really been saying anything at all!"

CHAPTER TWO

# The Need for the Arts

Paramhansa Yogananda, the well-known spiritual master, told a story of his visit to Lake Chapala in Mexico. He was accompanied by a student of his, an engineer.

"We stood together in silence," Yogananda related. "My inspiration was the contemplation of God's beauty in Nature. I attributed my friend's silence to the same cause. And then he exclaimed:

"'Just think of all the power you could get from this much water!'

"The view before us was the same. It was our outlook that differed.

"Circumstances," Yogananda continued, "are always neutral. It is our reaction to them that gives them their meaning for us, making them appear either good or bad, pleasant or unpleasant, useful or beautiful."

What is it that art defines for us? Our feelings, primarily. Feeling is seldom a deduction. It is a different faculty of understanding altogether from the intellect. In its own way it is as important as the intellect.

The mere fact, for instance, that the galaxy we live in contains billions of stars, and the universe as many billions of galaxies, hasn't any meaning for us unless that abstract knowledge generates some

29

reaction in us on a feeling level. Understanding is not synonymous with knowledge. It is born of the feeling awakened in us in response to knowledge: the sense of awe, perhaps, or of expanded awareness. Ignorance, by contrast, is not so much a lack of factual knowledge as an exaggerated reaction to whatever facts we do know: a reaction of fear, perhaps, or of isolation, with a resulting inward contraction upon the ego.

Feeling, then, is of two kinds: calm and impersonal on the one hand, and emotional on the other.

Science has made amazing inroads in its study of the nature of material reality. If, however, its discoveries awakened in us no appreciation for that reality, the information might as well be fed to the artificial "brain" of a robot and left there, like folders in a filing cabinet. As far as the robot was concerned, the information would have no more meaning than gusts of wind blowing leaves from a tree.

In the modern age, addicted to fact-gathering as we are, a person is praised if he functions efficiently, but whether he enjoys that efficiency is considered beside the point. Does an autoworker enjoy working on the assembly line? Who cares, as long as he gets his work done? Is a scientist thrilled over his history-making discovery? The question is not likely to arise. His feelings are not what make the front pages.

I held a job for a week many years ago in a sintering plant. The reason I took the job was that I wanted to earn enough money to go off and live as a hermit in the mountains. The work, in other words, paid well.

Every day at lunchtime the men who worked with me would sit around the railway cars and open their

lunch boxes. Wanting an environment of greater natural beauty, I went off into the nearby woods, where I ate in the serene presence of trees.

"You aren't supposed to go in there," one of the men objected one day. I ignored him. Fortunately, the foreman never discovered my eccentricity. Or perhaps he saw no major threat to company policy in my desire for temporary relief from the monotony of eight hours a day of slag and black dust.

It is cold logic however, and not feeling, that commands supreme respect in today's world. The cowboy of the western cattle range; the rising young executive on the precariously swaying corporate ladder; the brilliant chemist in his test-tube laboratory: These persons are depicted in popular fiction as coldly efficient, unsmiling, laconic, often sour tempered. Their hearts are imagined as efficient mechanisms driving them on to success at any price. They are not really inhuman; nor are they subhuman: They are merely non-human. We are supposed to admire them for their ability to draw a faster gun, outbid their competitors more ruthlessly, or mentally compute data more quickly than anyone else. Like the protagonist of an Ayn Rand novel, their smiles reveal a sense of superiority to the human dwarfs around them—people, in other words, who let their feelings show in the face of serious issues.

As well call a robot a hero. Without feeling, what is the value in even the greatest discovery? What matter the vastness of the universe or the intricacies of the atom to the blindly staring indifference of a mechanical brain?

Our feelings help us to complete our humanity. They enable us to function better, even intellectually.

31

Science, however—unfortunately—has persuaded us that to perceive reality as it is, our feelings must be eliminated.

Unquestionably, feelings do cloud perception, when they take the form of emotions. Consider people who become emotional at a ball game, perhaps because of an unpopular decision by the umpire: How rarely do they ask themselves, "Was the umpire perhaps, after all, only being fair?"

Scientists are rightly wary of emotion. It would be absurd for them to range themselves into flag-waving fans in the laboratory, rooting for one chemical substance against another. Scientists do their best to keep their emotions under control while they work. They know that the emotions, like ripples on the surface of a lake, distort any image reflected in the mind.

Feeling, however, is not necessarily the same thing as emotion. When a lake's surface is calm, the images reflected in it can be clearly perceived. A well-ground telescope mirror provides exact images of distant stars and galaxies. Similarly, when a person's feelings are calm and impersonal, they actually enhance his perceptions of reality.

Calm, impersonal feeling is the essence of true discovery. It is that sense of wonder which was described by Keats, the Nineteenth-Century English poet, on the occasion of the first sighting of the Pacific Ocean by Europeans. Its discoverers stood there (he wrote), "Silent, upon a peak in Darien." This almost mystical sense of wonder and awe was described also by Einstein, who called it the essence of all true scientific discovery.

Our humanity is reduced by half—indeed, by much more than half—when feeling is eliminated from our quest for understanding. It is only the minor scientist who takes pride in his ability to remain unfeeling in the face of discovery. (And pride itself is a distortion of perception. It, too, moreover, is an emotion.) Those great scientists to whom we are beholden for discoveries that have changed the face of civilization have been men and women of deep feeling—endowed, usually, with intense enthusiasm for their work.

Intellect is only one side of the coin that man pays for the insight he seeks into the true nature of things. The other side of that coin is feeling. Scientists make the worst case for objectivity when they urge the elimination of feeling altogether. Instead, they should encourage *clarity* of feeling, as much so as they encourage clarity of intellect.

Human nature inevitably rebels against this one-sided attitude toward reality. In reaction against it, artists, and others in whom the feeling faculty is keenly developed, have affirmed the supreme importance of feeling. Equating feeling with emotion, however, they have allowed themselves to be swept up in cyclones of confusion, and have called the chaos itself meaningful.

Artists have persuaded many people, moreover, that the more a work of art expresses irrational passion, rage, hatred, and other surging but negative emotions, the more "powerful" that work is, and the more "meaningful."

Science is right in its claim that the emotions are an obstacle to understanding. *Calm feeling,* however, is the very essence of deep understanding. Calm

feeling is *intuition*. And intuition is that feeling which appears when both the intellect and the emotions are lifted into a still, inner perception of the truth. Without intuition, profound insights are simply not possible.

The popular belief that identifies genius with a high IQ is a myth. Intuition brings clarity to both feeling and intellect, but a keen intelligence is not necessarily *intuitive* intelligence. Look at the vast numbers of men and women with a "genius" IQ who accomplish nothing in life. One person I know has an IQ that goes, as the saying goes, "right off the map." The high expectations held of him during his school years only served to deepen his later sense of failure.

We need intuition, and not merely keen intelligence. Without intuition there is no way for us to transcend the limitations of human nature and *know things as they are.*

It is in this sense, indeed, that we need the arts— not as a kind of vent for pent-up emotions, but because the arts, more than most other activities, can help us to develop intuition and to direct it wisely.

This is why the arts are so important to society as a whole. Creative artists are often described as "intellectuals," but to call them that does a disservice to the real role of art in human affairs. Granted, artists often *are* intellectuals. Art may, moreover, offer discerning social commentary; it is needed in this role also. Its scathing satires are more effective than any political harangue. But even where the arts serve the cause of intellectual criticism, their effectiveness is due above all to their appeal to our feelings. Analysis

may supply convincing *reasons* for change, but the arts have the power to awaken in us the *desire* for change.

During the time of unrest during American colonial times, analysis of the economic facts suggested that independence from England was desirable. But it was the resentment felt in the colonies, born of people's awareness of these facts, that cried out, "Give me liberty or give me death!" Without that cry and many others like it, there would have been no American Revolution.

Intellect without feeling is an armchair traveler. Feeling is necessary, for action. Feeling alone can move people to leave their homes and get out and see the world.

Intellect has been in the ascendent for many centuries. It wasn't science that gave it its first push. It was the ancient Greeks—Aristotle, particularly—who launched its career in Western thought. Thomas Aquinas, the greatest Catholic theologian, formulated his famous definition of man as "a rational animal." The German philosopher Hegel insisted, "All that is real is rational, and all that is rational is real." Theological definitions, in carefully phrased dogmas, were accepted long ago as virtual substitutes for the truths they defined. Long before the advent of modern science, the West was already over-balanced on the side of the intellect.

The time has come now for a correction toward feeling—not emotion, but calm feeling. And the arts can help greatly to bring about this correction.

The arts can help to prevent people in our too-technological world from becoming mental and spiritual paraplegics, able to observe events but

unable to get involved in them. Today more than ever before the need presses upon us for a return to our humanity. It isn't logic alone that guides us even in our most logical decisions: in what investment to make, what direction to take in business, what to do with our lives, or even which of several paths to pursue in a scientific investigation. We must *feel right* about the steps we take. The arts, because they encourage rather than deny feeling, are a means of bringing feeling and reason together in a shared relationship which alone can lead to clear understanding.

Let us take a few examples of the power of art to stimulate feeling. Were it not for the involvement it brings us on a feeling level, we might have preferred it had François Villon, for example, simply written, "Time passes." Why, one might wonder, did he feel he had to repeat at the end of each stanza of his "Ballad of Ladies of Olden Times" the refrain: "But where are the snows of yesteryear?" (*"Mais où sont les neiges d'antan?"*)

Shakespeare wrote in *A Midsummer Night's Dream:*

> The poet's eye, in a fine frenzy rolling,
> Doth glance from heaven to earth, from earth to
>     heaven;
> And as imagination bodies forth
> The forms of things unknown, the poet's pen
> Turns them to shapes and gives to airy nothing
> A local habitation and a name.

Had Shakespeare been writing a sociological treatise, he might have contented himself with the bare statement, "Poets have a lot of imagination."

Mozart, instead of giving us essays on the importance of being happy, wrote music that touches our imaginations and makes us *feel* joy.

Botticelli, instead of depicting spring literally, with crocuses coming out of the ground and fresh leaf buds opening on the trees, painted young maidens dancing in a mood of springtime exhilaration. A fancy-inspired zephyr, humanized, blows upon the air around them. Botticelli touched our *feelings* about springtime; his painting, *Primavera,* is deservedly famous.

The ancient Greeks, too, though amazingly realistic in their sculptures, yet offered poses of dignity and grace that one rarely beholds in so-called "real" life. Their work was idealized; it sprang from deeper currents of human consciousness than it could have, had the artists merely depicted the (presumably) pot-bellied human specimens they beheld plodding about the streets of Athens in their day.

Art serves an important purpose in the refining process of civilization. I don't mean to lay too heavy a burden of responsibility on artists; it might deprive them of the fun and delight of creative self-expression. Still, they should also recognize that they do have a duty—not only to society, but to themselves. The function of art is more than helping us to "get in touch with our feelings," as the popular expression goes. It is to help us to *refine* those feelings.

A poem would be more highly thought of if it compared a sunset to the subtle nuances of color in human life than it would be if it likened the setting sun to a squashed tomato—or, leaving comparisons aside altogether, if it stated simply, "I saw a sunset today. It was red and pink."

Unfortunately, the bias toward intellectuality even in the arts has become so much the vogue that artistic expression itself is often treated as an intellectual game. I saw a cartoon once showing two persons at an art gallery gazing at a framed, but blank, canvas. One of these persons, reading aloud from a guidebook, quoted: "And during this period of the artist's life he was fascinated by vast expanses of pure white."

It is, in fact, our intellects that a great deal of modern art tries—not to enlighten, but to stupefy. Perhaps there may be found in this pseudo-intellectuality some recognition of the need to balance reason with feeling—the thought, maybe, that by shrinking the head the heart will seem bigger. But the arts can bring clarity to feeling without stunning our intellects. As I said, we need both of these faculties.

The intellect alone can lose itself in a mental labyrinth from which there is no logical escape. Consider that intellectual pretzel: the Cretan who declared, "Cretans *never* tell the truth." Did he—a Cretan himself—really mean "never"? If so, what can one believe? The intellect contemplates this conundrum only briefly before feeling rushes onto the scene and cries, "Enough of this nonsense! The statement is absurd, and I won't waste further time on it."

In the next chapter we'll consider how art and science can cooperate together as partners in the search for understanding.

# Art and Science:
# A Perfect Partnership

I'm giving art and science a specialized meaning here.

By science, I don't mean the *sciences* (physics, chemistry, and the like), but those practical methods which are necessary for success in every field. There are techniques that help us to become expert at whatever we are doing: in the laboratory, of course, but also in business, politics, family life, sports, the arts. There may be many different techniques for helping us to achieve the same ends, but to ignore the need for methods and techniques altogether is to remain forever a dilettante, relegating oneself to relative incompetence in one's chosen field.

If, for example, an artist has no idea of the proper way to mix colors or to apply his brush strokes; if he is ignorant of the principles of symmetry and perspective: then whatever inspiration he feels in his heart will remain forever uncommunicated in his paintings.

And by art I mean not *the arts*—painting, sculpture, music, and literature—but that subtle attunement which is needed in every activity if one is to achieve the highest success. A person may know, and follow, all the rules of business and yet remain a mediocre businessman. A golfer may learn over

years the best ways to hit a ball and yet never achieve what it takes to win a tournament. A singer may be musically trained, may have a beautiful voice and know how to place his tones perfectly, yet never achieve the stature of a great singer.

Thousands of young people every year graduate from art school, where they were taught more, perhaps, than Leonardo da Vinci ever knew about the techniques of painting; at least they received the benefit of subsequent centuries of experiments in painting. But are the art schools turning out artists of comparable genius to Leonardo's? Even if a person is so blindly loyal to modern art that he insists that some of these graduates, anyway, deserve such comparison, he is unlikely to go so far in his loyalty as to claim that *every* graduate is as good as Leonardo.

The grades the student receives in art school, moreover, though they reflect his level of intellectual knowledge and his technical mastery, are no sure gauge of his future success in the arts. The poorest student may actually become the best artist, later on.

Many of the most successful people in every field of activity did poorly in school. Some of them never even went to school. Einstein's teachers marked him for certain failure in life. Edison was sent home by his schoolteacher with a note saying that he was too "addled" to learn anything. Countless similar examples are to be found in every field, underscoring a truth that cannot but be an embarrassment to pedagogues. For people of the highest achievement in all walks of life are very often those who received little or no formal training in their own fields of endeavor.

This does not mean they ignored the scientific aspect of their subject—the rules of the game, so to speak. It means, rather, that they learned those rules by experience rather than from books, through trial and error, and by their inner feelings rather than through blind obedience to tradition. Lessons learned in this way are often absorbed on far deeper levels, for people then develop an insight that is born of direct experience, which enables them to intuit the rules and thereby to minimize their reliance even on trial and error.

A young would-be composer once asked Mozart, "What do I need to do, to write a symphony?"

Mozart replied, "The symphonic form is difficult. You'd need to practice writing simpler forms first, such as sonatas. Once you've gained proficiency in those, try writing chamber music. Only after you've learned the limitations and possibilities of numerous instruments will you be ready to try your hand at symphonies."

"But," the young man objected, "*you* didn't follow that procedure. You wrote symphonies from the very beginning."

"True," replied Mozart, "but then, you see, I didn't have to ask that question."

The rules for competence in any field are there to be discovered, whether on some deep level of memory (perhaps from some former lifetime) or by a simple process of trial and error. Since they are spelled out in the classrooms, they are more readily accessible to formal students, but for every rule there had to be someone, at some time, who discovered it. When finally it entered the textbooks it was because enough people agreed that it worked. The rule

wasn't accepted as canon merely because someone with sufficient influence declared, "It shall be done this way."

Formal study can be, for artistic people, an actual disadvantage. Solutions learned from others tempt one to accept a choice that is facile but not fully understood. They offer an "out" from the creative struggle of finding what may be uniquely appropriate to the case—for example to the piece of music one is composing.

In this matter I have had some experience, and not easy experience at that. For I am, among other things, a composer, and in that field have achieved a certain measure of success. Some of my music has won prizes in Europe; some has been selected for international airline audio programs; and a number of my albums have received satisfying reviews in magazines, newspapers, and on radio programs. I offer these facts not to boast, but simply to make the point that I've had direct experience in these matters. And what I've found is that lack of training, though it certainly presented difficulties at first, was not an insuperable obstacle to success. In some ways, rather, it proved an advantage.

Let me share with you briefly my early struggles in composition, a field in which I had virtually no training.

I began composing relatively late in life, at the age of thirty-eight. I don't mean I'd had no exposure to music until then. As a boy I studied the piano for a number of years, and practiced for hours every day. I never became much of a pianist compared to the child prodigies around, but at least I was in earnest. Later I studied singing also, and have always been in

some demand in that capacity. For years, also, I tinkered around at the keyboard, experimenting with different-sounding chords as I tried to sense how they flowed together in sequence, and what their different "moods" were. All my life, too, I'd loved good music, and had tried to *feel* the different states of consciousness that it expressed. All my life, moreover, unknown melodies had "floated" through my mind; I'd never written them down.

When finally I began writing music, I was able to "hear" chords in my mind. I had no idea what their names were. Basically ignorant in such matters, I sought advice wherever I could. Yet I found, increasingly, that people's suggestions didn't necessarily correspond to what I was "hearing" inwardly. At first I doubted my inspiration, but gradually I came to realize that the rules for writing music are not arbitrary: They are simply based on what has been found to work—on what satisfies the human ear. If a chord was unusual, that didn't make it necessarily wrong. Even parallel fifths, which are usually frowned upon, may sometimes sound right regardless of what the books say.

While I couldn't create my own rules, in my struggles to discover what sounded best I learned principles that I'd have had to learn in school. And I found it was often better not to have those school-learned principles as my guides: Unfamiliar with the facile solutions, I was forced to depend more on what my heart told me. The music I wrote was a true expression of my own inspiration.

The science, or methodology, in every field of expression is important; in whatever way we come to know it, we cannot express ourselves effectively

43

without it. But I recall what an effort of will I had to make in order to keep in mind some chord that I liked, while going on to see how that chord "worked" in sequence with other chords after it. Lack of formal training was definitely, in this sense, a disadvantage.

Science is necessary to understanding. But science is the lesser part of understanding. "Art"—that is to say, the subtle inspiration with which one applies the science—is the true essence both of understanding and of creativity. Art can never be taught, nor learned. The techniques of painting can be studied, but the subtle heart of painting must be discovered by the artist for himself. It can be neither described nor defined. If ever this art, so essential to high achievement in any field, can be acquired from anyone, it must come by a process of what may be called spiritual osmosis. It is a kind of magnetism, and must exist, well formed, in the person who transmits it and be received by a student of already-developed sensitivity.

A student of Leonardo da Vinci's, for example, would receive more of the master's intuitive grasp of art than he would by struggling to develop artistry on his own. The subtler the subject a person aspires to master, the greater the difficulty of success, unless he puts himself under the influence of someone who has already achieved mastery of that subject. This principle is well understood in the East, particularly in India, where the spiritual aspirant seeks guidance from a spiritual master, with whom he endeavors to attune his consciousness. His guru's magnetism is far more important in his struggles to learn than any instruction he might receive in words.

The essence of success in any field is too subtle to be received by verbal instruction alone. It is a *feeling*. It is, to be more precise, an intuition. One cannot say exactly *why* a thing is done better one way than another, but the choice depends not at all on guess-work. A person who possesses what some may call the "aura" of success *knows* what has to be done in the things he does. *How* he knows, even he may not be able to say. He knows only that he must hold firm to this inner knowing even in the face of all reasonable advice to the contrary.

This inner knowing is not necessarily a belated recognition of already-known principles. It may also result in the discovery of completely new principles. St. Francis of Assisi, before beginning his spiritual quest, had a vision of Jesus in the little ruined chapel at San Damiano. Jesus said to him, "Francis, rebuild my church." Francis assumed that he was supposed to renovate that ruin. Accordingly, he applied himself to the task with a will. Ignorant of the principles of architecture, however, he set himself to figuring out on his own how the job might be done.

There was one problem that baffled him: how to rebuild a collapsed arch. Through prayer he was inspired to build a new kind of arch, unknown to the architecture of his day. His arch became a standard form in later church architecture.

The science of a thing is its methodology. It embraces the techniques that are necessary for success in that field. The art of a thing, on the other hand, is that inner sense, that intuitive perception, without which one cannot apply those techniques effectively. In this sense, science and art are natural

partners. Each without the other is like a runner with only one leg.

If one is forced to choose between the two, however, art is the essential choice. Without art, highest achievements are impossible. *With* art, on the other hand, even unprofessional technique may be excused.

An example of art that was unschooled but inspiring, because deeply felt, is found in some of the early Christian frescoes in the catacombs around Rome. Inspiration is the rarest treasure of art. A painting done with merely technical skill, but with an absence of artistic feeling, may be clever, but it cannot be profound. If it succeeds in awakening some deep response in the viewer, the credit is the viewer's, not the artist's. An uninspired piece of music that obeys all the rules may for a time be "listenable," but sooner or later it will grow tiresome.

Deep responses on a feeling level cannot be evoked by leatherwork or other handicrafts, no matter how skillful the craftsmanship. Such feelings *can* be evoked, however, through what for this very reason are known as the "fine" arts. This kind of art is necessary to civilization, for it helps to maintain a balance between reason and feeling, a balance that is threatened not only by science, but by the "creeping sophistication" of intellectuality.

It remains to be asked, then, whether feeling can be as clear a guide as reason to the nature of reality.

# The Importance of Clarity

Many artists, aware of the importance of feeling to artistic expression, make the mistake of abandoning themselves to their emotions. The question of emotional *values* doesn't seem to occur to them. They find it sufficient to express those emotions forcefully.

Yet we all know that certain emotions cloud the mind, and are not therefore aids to understanding: anger, for example, jealousy, hatred, and excited passion of all kinds. Such emotions may be intense, but their very intensity is a tidal wave that sweeps everything before it. The more intense they are, the more easily they incite people to commit deeds they may later regret.

Not only can feelings themselves be unsettling or confusing: Confusion may occur also in the way artists express them.

Years ago, a woman of my acquaintance sang me a song that she'd written. All I remember now are the words: "I buried you in the tomb; now you follow me 'round from room to room." From sentiments such as these one might have expected the music to possess a certain lugubrious quality. Instead, it was jazzy and upbeat. While singing it, the woman moved her shoulders rhythmically, as though dancing gaily. The conflict between the

haunted horror of the lyrics and the jaunty lilt of the melody gave me a bit of a struggle inwardly to keep a straight face.

A work of art cannot convey clarity of feeling if it lacks self-consistency. Consistency must appear in every note, in every brush stroke, in every word. Such fidelity to one's theme is not always easy to maintain. Most works of art drop a few stitches here or there; sometimes they even lose their thread altogether. A song, for example, may begin with a haunting melody; it may even become famous for that beautiful first line. Inspiration expressed itself in those few notes, then lost its way in the undergrowth as the composer's concentration wandered. Such songs often degenerate into merely conventional statements, in this respect resembling a public speaker who starts to voice an important conviction, then ends lamely with the confession, "At least, that's what everybody says."

When writing a piece of music, the composer must hold every note, every chord, and (if it is a song) every word of the lyrics up to the feeling he is trying to communicate. There are no "fillers" in a true work of art.

I am reminded of the excellent stories of the British humorist P. G. Wodehouse. Passages through which a less conscientious writer might have moved hastily, as though passing through some drab corridor to get to the next room, are treated by Wodehouse as though the corridor itself offered fascinating possibilities.

In a story called "The Passing of Ambrose," Wodehouse's "hero" gets his much-loved top hat knocked off and trampled on in the crowd. The fun

of the situation centers in this proper young man's embarrassment at losing his hat, which gets returned to him in much-battered condition. The actual process of its return would have been passed over lightly by most writers, and treated with no special attention to details. Wodehouse, however, saw the matter differently.

A uniformed doorman walks up to "our hero," grandly bearing his prize. He is described without further elaboration as a Czechoslovakian Rear-Admiral. The story continues:

> "Here you are, sir," he said. "Here's your rat. A little the worse for wear, this sat is, I'm afraid, sir. A gentleman happened to step on it. You can't step on a nat," he said sententiously, "not without hurting it. That tat is not the yat it was."
>
> Although he spoke in the easy manner of one making genial conversation, his voice had in it a certain purposeful note. He seemed like a Rear-Admiral who was waiting for something: and Ambrose, as if urged by some hypnotic spell, produced half-a-crown and pressed it into his hand. Then, placing the remains on his head, he tottered across the lobby to join the girl he loved.

Great artists in every field—and P.G. Wodehouse was certainly a great artist in his chosen field—show a commitment to detail that lesser artists might consider insignificant. It is the minor artist who tells himself, "Well, after all, I've already made my point. The tray on which I'm serving my ideas has been polished to a shine. Why bother how the underside looks?"

To complete this illustration, a good artist won't over-polish, either. It takes art, not science, to "feel" when the right moment has come to stop. Wodehouse rarely committed the literary sin of over-polishing.

It is tempting, of course, to relax one's efforts once one feels his point has been adequately made. I remember the last note of a children's song I once wrote. There were two directions for the melody to go. One of them was downward; the other one, upward. The lower note would have ended the song in a mood of relaxation, and perhaps sleepiness—a legitimate ending, actually, except for one thing: The song expressed high energy; it was inspired by the innocently joyful life of St. Francis of Assisi. Here are the first and last stanzas:

> Hello there, brother bluebell:
> Play me a tune today!
> The breezes on the meadow
> Have made you look so gay!
> The meadowlarks are singing:
> Joy's in the air!
> Come set your bells a-ringing,
> You've gladness to share. . . .
>
> Hello there, dearest kinsmen:
> Pebbles and laughing brooks!
> You timid little beetles
> That hide in private nooks.
> God made us of His gladness:
> Come, then, and sing.
> To cure the world of sadness,
> Oh, ring, bluebell, ring!

Musical convention, and the melody also at that point, suggested the possibility of a sleepy ending. But was relaxation, I asked myself, the mood expressed by the lyrics? Surely not.

The other alternative was to take the last note higher: an unexpected ending, in this case. This choice would suggest release also, but upward—as if into superconsciousness. The decision was, in terms of the mood of that song, an important one, at least for me. I've always been glad that I decided to "take the highroad" toward a more expanded awareness.

Clear expression in the arts is a matter, first of all, of consistency: of knowing what you want to say, and of continuing to say that, specifically, without allowing yourself to get sidetracked unless there is, again, a purpose in the diversion.

For there are times, of course, when a change of pace can be helpful.

Shakespeare, as students of his art know, often deliberately broke the mounting mood of a play by introducing a comic scene. In these cases, his abrupt change of mood supported his over-all purpose. He knew when to relieve the tension in the story, and how thereby to help his audience to return to the central plot refreshed and ready for renewed action.

There is another aspect to the question of clarity in the expression of feeling. For not only must the guiding purpose of a work of art be *expressed* clearly: The purpose itself must be clear, not muddy and uncertain.

When emotion is expressed in art, it may be of a kind that obscures people's understanding instead of clarifying it. In this case, the clearer the expression of that feeling, the muddier the results.

Anger is an example. Statements made under this influence tend to be rash, and are seldom well considered. A work of art that expresses anger may stir prejudice in others. The clearer the artistic statement in this case, the greater the lack of clarity it conveys.

Intensity of feeling in a work of art doesn't guarantee its validity, considering validity from the standpoint of human values. Emotions may be compared to water flowing through a hose: The intensity of the flow can be increased by tightening the nozzle. The heart's feelings, similarly, can be squeezed by excitement, meanness, or anger, and with the thinness of emotional flow give the illusion of intensity. But in thinness there is no fullness of feeling, only a sharp sting.

Contractive emotion is often revealed in a certain thinness in the voice, a hardness in the facial expression, a jerkiness of bodily movement. These things find expression, even inadvertently, whatever the art form. Works of art that try to express intensity in this way reveal the brittleness of an unworthy cause.

An inward contraction upon the ego, in whatever way that contraction is caused, limits a person's ability to experience deep feeling. Though its expression through the arts may seem violent, it is (to quote Shakespeare) "full of sound and fury, signifying nothing." The more strongly negative, especially, an emotion is, the more it narrows one's awareness of broader realities.

Anger, like other negative emotions, contracts upon the ego and therefore squeezes its perceptions. One feels for a time the excitement of personal involvement. Later on, however, when the mood passes, one finds that, as with a tightened hose

nozzle, many "flowers" in the flower bed have not been watered. The flow of energy was too thin to achieve the balanced perceptions of wisdom.

A work of art, then, may be "powerful," and yet express emotions that diminish, rather than increase, the clarity of our understanding. The more agitated an emotion, the more likely it is to produce chaos. Clarity of feeling is as important as clarity of reason in any quest for understanding.

An example of the importance of clear feeling to clear reasoning may be seen in a statement—apocryphal, surely!—that has been attributed to a Hindu in India. This devout man, anxious to convince a Westerner of the ancient greatness of his country, announced to him, "In all the archeological excavations that have been done in India, not a single wire has been found. This *proves* that in ancient India we had the wireless!"

When the feeling faculty is strongly biased, reason will usually support that bias.

Clear reasoning depends not so much on an absence of feeling as on *clarity* of feeling. When one's feelings are charitable and expansive, for example, reason inevitably follows suit. It isn't really possible to divorce the two, so long as one's feelings are restless. But for the feelings to be calm, they must be expansive, not contractive; kindly disposed, and not angry, rejecting, or aggressive. Without clear, calm feeling, reason will not even be aware that a broader view exists. Certainly, in any case, it will never embrace such a view.

Clarity of feeling is essential to true wisdom. It is essential also to great art. Because emotional feelings obstruct clarity, art, when it is necessary to express

53

such feelings, should set them in contrast to feelings that are clear.

Selfishness, for example, is better portrayed not alone, but in comparison to generosity. Jealousy can be contrasted with loving understanding, or with an acceptance of the other person's right to develop and learn by his own mistakes.

Art, in this way, can suggest solutions to life's problems. And to do so is, surely, its higher purpose. For there is no value in art that leads people into a labyrinth of confusion out of which there is "No Exit."*

For art, if it is well expressed, has the power to draw people into a vortex of its own feeling. If people are susceptible to the temptation to kill themselves, for example, a work of art that enhances that mood may push them over the edge. This actually happened during the 1930s, in response to a song called "Gloomy Sunday." This song was aired frequently on the radio for a time. At last it was banned because listeners, caught up in its mood of life-rejection, were committing suicide.

A woman author named Angie Fenimore, describing a near-death experience she had had, mentioned the attraction she had once felt toward "heavy metal" music. Her near-death experience came as the result of her attempted suicide. Fortunately for her, her life was saved. In her book, *Beyond the Darkness,* Fenimore describes the dark state into which she entered while out of her body. It was a place that resonated with her own dark

---

*The title of a depressing play by Jean Paul Sartre.

mood of despair. What she realized was that the vibrations there were identical to those she'd absorbed in her enjoyment of that music.

After her revival she was horrified by this realization, and refused to listen to the same music again. Ever since, Angie Fenimore has tried to persuade people that "heavy metal" and other music of that type, with its angry, hypnotic beat, is a moral and spiritual disease. Indeed, she says, it is satanic.

The effect of art on a person's consciousness may also be subjective, of course. If beauty, as is often said, lies in the eye of the beholder, so also must ugliness. In both cases, however, this is true only to a certain extent. The subjective element in people's reactions is no justification for emotionally troubling works of art. Rather, it underlines more strongly the artist's responsibility, both to the world and to himself, for expressing high and uplifting inspiration as clearly as possible. For even a hint of darkness, in its mood of despair, may affect those who themselves are in despair, influencing them to abandon the struggle altogether.

There is, indeed, such a thing as induced negativity. When negative emotions are aroused in response to a work of art, there is usually some form of mutual resonance.

The artist should do his best, therefore, to make his art a medium of upliftment, and not be willing to encourage negativity in others. He should realize that, as the originator of his art, and as the one, therefore, closest to its source of inspiration, he cannot but inflict more of its pain—or, for that matter, its joy—on himself than on anyone else.

He must also, moreover, bear the "karma" of any pain he inflicts on others, as he is also blessed by the good karma of any joy he gives them. How much of this blame or blessing is his due, and how much of it is due to the public in its reaction, is of course impossible to quantify. That a work of art can affect people is self-evident, but the fact that their subjective response is also part of the equation makes it possible for artists to claim justification for their work by such airy statements as "Negativity is in the eye of the beholder."

Their claim can be answered by viewing the effect of art on non-human subjects.

For a response to art that is completely impersonal, it would be difficult to imagine a better example than the effect music has been demonstrated to have on plants.

Plants are not reasoning creatures, though they seem to have a primitive analog of a nervous system; at any rate, they respond to a variety of stimuli, and even to human emotions. Love, when directed at a plant, has been known to make a plant flourish. Negative expressions, such as the repeated statement, "I hate you, you're so ugly!" have been found actually to result in the plant's death.

Now, therefore, consider the effect of music on what must be assumed to represent the most unbiased "audience" anywhere. A loudspeaker placed beside a planter box has been found repeatedly to evoke reactions in plants, whether positive or negative depending on the kind of music played. When the music was a Strauss waltz, the plants flourished. Classical music, too, produced beneficial results— far more so than an absence of music. Jazz, amus-

ingly enough, proved to have a stimulating effect on radishes, and presumably would similarly affect other vegetables that have a slight "bite" in their taste.

Rock 'n' Roll, on the contrary, awakened an entirely negative response. Plants subjected to it wilted and finally died.

Plants subjected to music they liked put out tendrils toward the loudspeaker, as if wanting to embrace it. When rock 'n' roll was inflicted on them, however, they sent tendrils out in the opposite direction, as though trying desperately to escape their planter boxes.

People may, and many of them do, try to convince themselves that the nervous rhythms in popular modern music don't harm them, simply because they like that music. They are mistaken. While it is true that human beings have the free will to develop tastes far outside their natural, instinctual patterns, their own nervous systems respond independently of their decisions. People may even persuade themselves that they *like* these nervous reactions—nervousness, tension, violent emotions—and that bitterness, perhaps, and the desire for revenge are perfectly normal sentiments. The human nervous system, however, remains unpersuaded. Under stress, it gradually breaks down.

No human being is unique in this respect. Certain influences have a beneficial influence on the human nervous system, and on human nature generally, regardless of anybody's conscious reaction to them. And certain other influences have a universally depressing, even a destructive, influence.

A challenge given to us at birth is the responsibility to discover which influences work well for us, and which ones work against us and against all that we ourselves truly want from life. At stake is our health and happiness, and our ability to relate to the universe around us in such a way that we grow in wisdom.

Art, then, is a matter of more than taste—far more. There have been times in history when entire nations have embraced art forms that, over time, proved destructive. The "Marseillaise," for example, born of the French Revolution, fanned the public's zeal for it with its rhythm, and with its shout for the "impure blood" of the invading army. Many national anthems, including our American, are bloodthirsty in their sentiments. Fortunately, since the melodies and rhythms are upbeat, most people pay scant attention to their lyrics. I was glad, however, when India adopted a national anthem of which the lyrics, too, extoll positive values.

It would be difficult to imagine Nazi Germany reveling in the devotionally inspiring music of Bach's "St. Matthew Passion." And of course, it didn't. The musical taste of the Nazis leaned more toward works that boosted the national ego, such as the grandiose operas of Richard Wagner.

England, during its empire-building era, loved music that affirmed those colonial ambitions. "Rule Britannia," and other music suitable for troops of marching soldiers, was universally popular.

We don't know much about popular taste in music during more distant times, but other art forms fill that gap for us. The monuments left by Rameses II, the conquering pharaoh, certainly give

the impression of arrogance. And Shelley's poem, "Ozymandias," describing his feelings on viewing the broken remains of Rameses' statue at Luxor, is a fitting testament to the final results of those warlike ambitions.

People, in their eagerness for war, may have convinced themselves that warlike sentiments in music and in other art forms were right and good, but history has always shown in the end that such sentiments had a harmful effect on their inner harmony and on their very sanity. By long, and at times bitter, experience human beings learn which feelings work for them, and which, in the end, do them a great disservice.

The popular music of our own times, with its ruthlessly heavy beat, may be seen in this context as a bleak intimation of coming tragedy.

There have been times in history, of course, when the general taste in art was beneficial, and when works of art encouraged attitudes of kindness and tolerance. The more a nation embraces positive artistic expression, the more it flourishes in every aspect of life. This was what Shakespeare expressed in the beautiful speech he put into the mouth of the Duke of Burgundy in *King Henry the Fifth* on the occasion of the duke's plea in favor of peace.

> Let it not disgrace me
> If I demand, before this royal view
> What rub or what impediment there is,
> Why that the naked, poor, and mangled Peace,
> Dear nurse of arts, plenties, and joyful births,
> Should not, in this best garden of the world,
> Our fertile France, put up her lovely visage?
> Alas! she hath from France too long been chas'd,

And all her husbandry doth lie on heaps,
Corrupting in its own fertility.
Her vine, the merry cheerer of the heart,
Unpruned dies: her hedges even-pleached,—
Like prisoners wildly overgrown with hair,
Put forth disorder'd twigs: her fallow leas
The darnel, hemlock, and rank fumitory
Doth root upon; while that the coulter rusts
That should deracinate such savagery. . . .
Even so, our houses, and ourselves, and children,
Have lost, or do not learn, for want of time,
The sciences that should become our country;
But grow, like savages,—as soldiers will,
That nothing do but meditate on blood,—
To swearing, and stern looks, diffus'd attire,
And everything that seems unnatural.
Which to reduce into our former favour
You are assembled; and my speech entreats,
That I may know the let, why gentle Peace
Should not expel these inconveniences,
And bless us with her former qualities.

The appeal to higher sentiments is surely the chief reason why certain works of art are universally recognized as great. Fads of the moment are like waves, rising, falling, and at last forgotten altogether. The underlying realities, however, remain constant. Once the excitement of the moment passes, people find themselves returning to these realities again and again.

I recall an evening I spent years ago in a New York theater, where the Joffrey Ballet was performing. One dance that evening took a novel approach to the subject of creativity. The idea seemed to be that if an artist could keep on evolving fresh acts of creativity out of every preceding act, he would be able to maintain a high flow of creativity. The dancers on

the stage projected new movements out of the preceding ones without ever returning to a position of rest at their own center.

The result was unsettling. It was so clearly contrary to everything that is natural in life. For human beings live from within outward. They project themselves from their center outward to their periphery. It is from within that we draw our spiritual sustenance, not from our periphery.

This fact can be observed everywhere in Nature. The very difference between natural fibers and those which, like nylon, are man-made, is that natural fibers contain a hole through their center, which permits the life force to flow out to all parts of the plant. Artificial fibers, on the other hand, are developed purely for their appearance; needing no passageway for the life force, they are solid throughout.

Everything a human beings does, when he loses his attunement with Nature, is done at his periphery. Every reference back to himself is inward from that circumference. Nature, on the contrary, radiates outward from its core in everything. It is, as Paramhansa Yogananda wrote in *Autobiography of a Yogi*, "center everywhere, circumference nowhere." And human consciousness, until it is rooted in wisdom, may be described contrastingly as "circumference everywhere, center nowhere."

A great work of art reflects attunement to the natural order. Its view of people, for instance, in one way or another takes into account the way they see themselves, and not only the way they look to others from without. Usually, such a view is compassionate. If it mocks, the mockery itself carries a suggestion of self-reproach.

If we ourselves don't return repeatedly to the inner wellsprings of our being, we become starved, eventually, of inspiration. Great art is a reminder to us to return ever and again to our own center within.

The choreographer of that dance at the Joffrey Ballet would probably, of course, insist that I have no right to tell him how he ought to interpret life. And of course, he'd be perfectly right. I'm not trying to insist that anyone do anything he doesn't want to do. All I say is that that dance was not true to life as common sense tells me it is. Let everyone choose as he wills, but objective reality doesn't support wrong choices. In that choreographer's declaration of artistic freedom, he'd do well to understand that he has deprived himself of a higher freedom: the freedom to express his own nature as it is, in truth. Until one does so, he is never free.

The search for understanding is a process of perpetual discovery, not of mere affirmation. This is as true for the artist as it is for the scientist. Artistic creativity is illusory if it is viewed as an opportunity to create new realities.

Great composers have often remarked that the music they wrote was not of their own making: that it existed already, and was simply awaiting their discovery. Had that music not been a creative *potential* from the very beginning of time, it could never have come into being.

Art can inspire us with fresh insights into reality. The feelings it expresses and evokes in others are valid only if they promote our quest for greater understanding. They are invalid if they obstruct us in that quest.

62

# Clarity Is Directional

One of the illusions inherent in the search for values of any kind is the expectation of finding absolutes. To put it humorously, that expectation is one of the sand traps on the fairway of life. Once a golfer's ball drops into this sand trap, he may find himself hacking away at the ball a long time before finally he lofts it onto the green.

To put it more seriously, the universe we live in is ruled by relativity. I've made the case for relative values in my book, *Crises in Modern Thought;*\* here is not the place to repeat those arguments. Briefly, what I said there was that, where moral and spiritual values are concerned, it is realistic to view them as relative—not absolute, but *directional* in their relativity.

When it comes to artistic values also, many people are as committed to their own ideas, and as defensive of them, as the most dogmatic preacher declaiming on Sunday morning from his pulpit. There is nothing extraordinary in this attitude. Quite the contrary, it is a sign merely of immature thinking

---

\* I intend someday to change this title to *Out of the Labyrinth.* The subtitle will read, *"For Those Who Want to Believe, but Can't."* Look for this new title, if the other is no longer available.

to be incapable of imagining the existence of any reality other than one's own. And very few human beings are fully mature, either emotionally or intellectually.

What dogmatism generally accomplishes, whether in theology or in the arts, is to limit one's concepts to the unprovable. In another book of mine, *Education for Life,* I state what I've called, humorously, Walters' "Law of Dogmatic Proliferation": *"The weight of dogmatism increases in inverse proportion to that of the evidence people offer in its support."* Let's face it, what we are dealing with in art is a human, not even a religious, phenomenon.

Religion is a means of helping people to prepare themselves for eternity by transcending their earthly attachments. Art may—and in fact ought to—inspire us toward higher potentials. If at all it does so, however, it must first portray us at our present stage of understanding. Only from this point can it inspire us to reach upward, toward our higher potentials.

Art is not a priesthood. The artist does not have to be ordained by any clerical hierarchy before picking up his brush or sitting at his piano and composing. François Villon, the medieval French poet, was a thief, yet he is recognized even today as a great poet. The moral character of artists is far less an issue, generally, than their artistic ability.

Yet whatever the artist creates will, in some way, reflect the sort of person he is. If he is morally degenerate, that degeneracy will infuse itself, however subtly, into his art. If we hang his paintings on our walls or play his music in our homes, we open our hearts to him, in a sense, as a human being. If his character is not compatible with the character we

desire in our friends, then, even if we find his conversation pleasant, there will be, in the influence of his presence, a subtle threat to our deeper peace and harmony. The Tempter himself has often been depicted as a charming fellow, but do we really want that kind of fellow for a friend?

What the artist offers us through his work, when all else has been said, is himself. And what we offer him in return is, again, ourselves. A drunken painter may be hailed as great by a nation of drunkards. He may be accepted, even rightly so, as an excellent craftsman. But he would not deserve to be considered, in the highest sense, a great artist. A person's art expresses who he *is*. His goal should be to reach out toward ever greater clarity in himself. Art, then, even if it doesn't express much clarity, should be a process at least of *reaching out* toward the achievement of clarity.

The drunken artist, for example, who longs in his heart to reclaim his dignity and achieve self-mastery will express that longing through his work. There will be, therefore, a measure of dignity, even of beauty, in his art despite his obvious weaknesses. Art represents the *inner* man—that person who the artist longs to be, and not the low fellow whom others judge harshly by his behavior. More inspiring, often, is this inner longing for betterment than the smug self-righteousness of one who never drinks, never gambles, never "runs around," but who, also, never reaches out toward his own higher potential.

The drunken artist, on the other hand, who wants only to share with us what it is like to be drunk, may reveal a certain power of self-expression, but it will be a power to depress others, not to inspire them.

Clarity of feeling, and clarity therefore also in the arts, is directional. It is not static, but moving: a movement either upward or downward depending on the hopes and aspirations, or the cynicism and despair, it expresses.

CHAPTER SIX

# Clarity of Feeling
# Becomes Intuition

There was a spate of stories in fiction early in the Twentieth Century that involved arrogant but diabolically clever men whose command of the facts was so complete that they could predict beyond the shadow of a doubt what the outcome of any human being's behavior would be. Being diabolical, of course, they used this information to lead others inexorably to their destruction.

Those stories, though works of fiction, reflected a widespread conviction—a mere superstition, really—that reason would prove to be the ultimate guide to understanding, and that reason was therefore the key to gaining complete mastery over Nature. This conviction found expression during what proved to be the "swan song" of science as a purely materialistic discipline.

For the heyday of the materialistic sciences came during the Nineteenth Century. That was the era when front-ranking scientists could declare without blushing their belief that the universe would someday be completely explained in three-dimensional terms. Even by the mid–Twentieth Century, people (no longer the front-ranking scientists, however) were still claiming that virtually everything that needed to be known about the universe was known

already, and that the scientists of the future would face merely the task of clearing up a few minor areas of uncertainty.

Early in this same Twentieth Century, however, physicists were already probing the significance of a universe that transcended reason altogether. It wasn't that they were saying that the true state of things is irrational, but only that it is so far beyond human reason that our intellects must remain forever incapable of understanding it. Far from being predictable, there is an element of uncertainty in the very movement of the atoms that makes reason seem like a wandering child, lost on pathways unknown and probably, to mankind, eternally unknowable.

One thing is now certain: Reason is not the key to ultimate understanding. For one thing, there are simply too many facts to be taken into consideration for them to be absorbed by our limited brains; too many facts that defy rational comprehension.

In India, in 1959, I came upon an ancient manuscript that accurately predicted specific episodes in my own life, as well as in the lives of countless other people living today. It described events that had already occurred in my life, of which I myself knew nothing but which I was able later to verify. Was the text a fraud? Maybe, although it would be unusual for anyone else to know things about me that even I didn't know. So, then—who knows? Maybe it was genuine. The very fact that, even today, rational human beings might entertain the mere possibility of its genuineness shows, if nothing else, how thin the ground is on which we erect our rational edifices.

The scientists of our day haven't confronted the possibility of anyone in ancient times being able to predict the lives of individuals living so far in the future as our own age, but science needs no such line of questioning to be convinced that our hopes of grasping anything, really, in its entirety by our intellects alone is a delusion.

What about feeling, then? Is feeling a truer guide to the real state of things? Or are we human beings destined by our feelings as well, to remain forever ignorant concerning the ultimate verities?

I was born and grew up in Romania, though my parents were American. (My father worked there as an oil geologist.) When I was a child in that country, I came down suddenly with a very high fever, accompanied by severe stomach cramps. The doctor summoned to treat me was convinced in advance that I had appendicitis. Poking and pressing my abdomen, she asked me repeatedly, "Does it hurt here?—here? What about here?" No, I said, and again, No, it didn't hurt in any of those places. Reluctantly at last, she concluded that I didn't have appendicitis after all, though I wonder if she didn't feel I *should have* had it. Probably, what saved me at last from a needless operation was the fact that, by this time, I was hurting all over.

So much for the "feelings" people often get about things. I've often heard people say, in direct contra-diction of the facts, "I *feel* (such and such) to be the case"—as if the fact that they "felt" it made it neces-sarily so.

Vincent van Gogh painted the stars as if they were whirling visibly through space. This didn't mean he actually saw them whirling, though he may actually

have imagined that he did so, since he is known to have lost his mind. Yet, the truth of the matter is that, whether or not we are able to see them move, they do whirl.

Art has often foreshadowed science in its descriptions even of material realities. Almost all of Jules Verne's science fiction stories, for example, though written in the Nineteenth Century, have been validated, since. Jonathan Swift, again, writing in the Eighteenth Century, described the moons of Mars. Astronomers didn't actually discover those moons until about a hundred years later. Jonathan Swift correctly described the respective distances of those satellites from Mars, and even their respective rates of motion.

Is there a faculty by which human beings can know things without recourse to objective evidence? That doctor in Romania "felt" something to be true that wasn't true. But Jules Verne, Jonathan Swift, and maybe even van Gogh seem to have been able to "feel" things that *were* true. Is there a way of knowing whether certain kinds of "feeling" are reliable?

To discover objective facts by such means is interesting, certainly. It is, however, less central to our need for understanding, as human beings, than the discovery of those truths which more closely touch our own lives. To know that a given course of action will prove helpful or harmful can be useful for everyone. And those arrogant rationalists of fiction, described at the outset of this chapter, could never, by their intellects alone, have made predictions of this nature infallibly. The variables are simply too many.

There *are* certain kinds of feeling, however, that do seem to provide true knowledge of future, or distant, or uncomputable events.

What level of feeling are we talking about? That doctor's mistaken conviction that I had appendicitis was based, certainly, on the wrong kind of feeling. In fact, accompanying the conviction was her attachment to the idea. Clearly, where there is bias there is an increased likelihood of error.

In the presence of anger, or passion, or emotion of any kind, similarly, there is also bias, and to that extent an absence of clear feeling.

There is a level of feeling, however, that transcends the emotions, and that should not be confused with them. This feeling comes when a person is *not attached* to the outcome. It comes when the feelings of the heart are calm. At such times, one's feelings become perfectly clear. And this calm level of feeling is the one faculty we have that gives promise of higher, complete understanding. It is what is known as intuition.

Intuition, when it is genuine and not the product of mere wishful thinking, transcends both the emotions and the intellect. It is the supreme human faculty for achieving true understanding. Scoffed at by egotists, who depend wholly on their intellects or their emotions, the intuitive faculty has, despite their disdain, brought to the human race those rare flights of inspiration that have resulted in great scientific discoveries and inventions, that have produced great works of art, and that have, in the teachings of those great and wise souls who appear in every age, been sources of upliftment for thousands of years.

71

For intuition goes beyond accessing factual knowledge. More importantly, it gives us wisdom to *cope* with reality. It also supplies that balance, that sense of fitness and harmony which is the essence of great art. Intuition contains a certain living quality that cannot be imitated.

Could anyone make a copy of the Mona Lisa as effective as the original? Not unless the artist were similarly inspired, in which case it seems more than likely that he'd paint something else. One aspect of intuitive inspiration is that it never repeats itself. Intuition is the living breath of a fleeting moment in time. It never returns to that moment. God Himself, it has been said, is inexhaustible. Divine inspiration is forever new.

Art that expresses more typical human emotions is not invalid, however. There is, as I said earlier, a directional relativity in self-expression that leads from relative error to relative truth. Emotional expression that leads toward greater clarity, rather than toward chaos and confusion, renders a service to everyone who is still caught in the whirlpool of that same emotion. It may not be intuitive perception, but it leads people in the direction of intuition.

Art, however, that expresses emotion only to revel in it, as though the emotion itself were a fundamental truth, performs a disservice to humanity, for it encourages people to affirm their own lack of clarity.

Ought an artist, then, to refrain from expressing his emotions? That is like asking, Ought a person to be what he is? How can one be anything else? I am not dealing with art as I might were I selling paintings in an art gallery, or were I a musician faced with the need to play for a living. I am not addressing all

artists. A great many works of art are either blasphe-
mous, trivial, or obscene. Many of them manage to
be all three of these together. Why get excited?
People simply are who they are; why tell them they
should be different? Shall anyone tell the wind
not to blow? I am addressing, rather, those people
whose aim, whether through artistic expression or
through appreciation of the arts, is to find a window
to deeper understanding.

A violinist of my acquaintance once remarked to
me, rhetorically, "After all, what could be more spir-
itual than music?" The question was a statement;
she wasn't looking for an answer, so I let it go. But
would anyone, including that violinist, lump
Beethoven's Ninth together with the honky-tonk
jazz in a New Orleans dive? There is nothing spiri-
tual about art, as such. Art is merely a vehicle for dif-
ferent states of consciousness. It is those states of
consciousness that may, sometimes, be spiritual. But
many of the worst Nazi butchers had excellent artis-
tic taste. Presumably they never plumbed the deeper
meaning in the works of art they stole, but, as the
saying goes, "they knew what they liked." Art is spir-
itual if it expresses spiritual qualities; it is worldly if
it encourages worldly involvement; and it is de-
monic if it expresses evil qualities.

Indeed, I think the first need for anyone who
aspires to create spiritual art is non-attachment to art
itself. For, let's face it, art is no sacred cow.

I once tried to persuade a friend of mine that self-
expression is meaningless in itself. To have meaning,
it must express not the ego, but the higher Self. He
was writing music at the time to express his "true
being," which meant, in his case, his personality.

And I wanted to get him to see the need for express-ing, not his personality, but his soul.

"Well, *you* know what it's like," he said, "writing music. It's something you just *have* to do. You your-self have been compelled to write it."

"I can tell you truthfully," I replied, "that if I never wrote another note in my life I'd be just as happy. The music isn't mine in any case: It's what I've been given to write. The job might just as well have been given to someone else. I have no need at all to compose, nor to write books, nor to sing, nor to lecture."

I used to feel that my lack of compulsion to com-pose music meant that I would never be a "real" musician. To me, this lack of compulsion demon-strated a lack of commitment. But then I realized that my commitment was very real. It was a com-mitment to truth, love, and God. It was to sharing with others my own search for eternal verities. It was simply not to any particular way of expressing this commitment.

Patanjali, the author of the *Yoga Sutras* (the uni-versally recognized scripture on yoga), wrote that when a person truly renounces avarice, all jewels (that is to say, everything one needs in life) will be drawn to him effortlessly on his part.

The important thing, ultimately, is the attain-ment of inner soul-freedom. It was my very lack of compulsion to write music, coupled with my desire to share inspiration with others, that enabled me to write music in the first place.

Intuition is calm feeling. To bring intuitive inspi-ration to art, one must transcend the emotions and find rest in the calmness of deep feeling. Necessary

for this level of clarity is devotion to God, or to Truth. Prayer and meditation are necessary. An attitude of receptivity, not of self-assertion, is necessary.

For, ultimately, we cannot *create* anything. All we can do is express, to the best of our ability, that which already *is.*

CHAPTER SEVEN

# The Hidden Message

All true art is allegorical. That is to say, it expresses more than what appears at the surface. Some art, like John Bunyan's *The Pilgrim's Progress,* or Hieronymus Bosch's gruesome paintings of hell, is overtly allegorical. And some art is not intended to express any hidden meaning. Art that is true, however, is true to the artist's inner being. It is this fact, above all, that makes it meaningful.

A reporter once asked P. G. Wodehouse, the English humorist (whom I already mentioned earlier), "Do you ever think about religion?"

"No," came the laconic reply.

When Wodehouse was asked in his old age whether he had a message to leave for humanity as his legacy, he replied, "I'm afraid my death will leave humanity one message short." He was, however, quite mistaken.

Wodehouse himself didn't realize the extent to which his very humor *was* his message, and also his legacy. To be serious doesn't require the furrowed brow, the set jaw, the nimbus of gloom. Wodehouse's creations of inspired lunacy provide a kind of "God's-eye view" of humanity, of people who do things with impressive self-importance, all the while appearing slightly—though always lovably—ridiculous. Wodehouse's message to humanity—though

76

never stated as such by himself—was to view life happily, with the attitude of a genuine friend and well-wisher of mankind. As someone said of him, "Behind the happy mask there lived a happy man."

Wodehouse didn't need to verbalize the value of courage in the face of adversity. He didn't have to give reasons for remaining upbeat in the face of a mailbox full of invitations to despair. His stories expressed these qualities more effectively than could have been done in any essay. It seems eminently fitting that Hillaire Belloc described him, when Wodehouse was still a young man, as "the best living writer of English."

There is a French folk song called "Passo Pel Prat" that is, judging purely by the words, a fairly average song about human love. Yet the music itself calls hauntingly to the deep longings of the soul for divine fulfillment. The words don't match the depth of the music, especially in Canteloube's beautiful arrangement, *"Chansons d'Auvergne."* The message of the music is conveyed so beautifully that the notes linger in the mind for days afterward, every time one hears them. It is this music that forms the background for the lovely last scene of Laurence Olivier's movie of Shakespeare's *King Henry the Fifth.*

Again, who can say what message, specifically, is conveyed by a Mozart sonata? I use the word, "message," but again I want to emphasize that art's message needn't be explicit. Mozart's message lay in the vibrations of his music. Emerson said it well: "What you *are* speaks so loudly, I cannot hear what you say." What Mozart gave us was, quite simply, his own outlook on life. It was a beautiful outlook: innocent, joyful, and courageous. His music tells us

who and what he was far better than any letter he wrote, and far better than the condescending, or jealous, impressions of him that were written by others. One whose consciousness is absorbed in music cannot always put into words what is in his heart. I think Mozart's letters and exuberant outward manner served, more often than not, as a mask to cover his deeper feelings.

The unspoken vibration is what art is really all about. The subliminal effect on our state of consciousness *is,* in fact, its message.

Debates as to the relative merits of different art forms—impressionism, realism, surrealism, and all the rest—are fairly pointless. Art expresses meaning not through its outer form, but in its underlying consciousness. The simplest line, when sensitively drawn, may express joy or sorrow, hope or despair, success or failure, depending entirely on the consciousness of the person drawing it. Art cannot be reduced, finally, to a formula. It is not explained if we speak of it in terms of technique. No mediocre artist, imitating the methods of a great one, could thereby produce a great work of art. To create such a work, one must be in some vital way great oneself.

I'll never forget seeing the Mona Lisa for the first time at the Louvre Museum, in Paris. Naturally, I'd already seen any number of prints of Leonardo's painting—in books, or hanging on people's walls. None of those reproductions, however, conveyed what I experienced when I saw the original. All I can say is, it was, in some inexplicable way, *alive.*

To re-state my point, art is a vibration. States of consciousness, also, are vibrations. Copies of a work of art can never fully capture that vibration, though

they may at least, by imitating the outer form, suggest to our minds that more living reality, and thereby help us to seek our own attunement with the original.

Most art draws its inspiration from the subconscious, not from higher levels of consciousness. Coleridge's famous poem, "Kubla Khan," is an excellent example of subconscious inspiration mixed with a hint of something higher. "Kubla Khan" is one of the loveliest poems in the English language. Its beauty lies more in the music of the words than in their literal meaning, and yet, for all that, its music is uplifting. It describes an unreal, fantasy world—not a true world—yet it contains a suggestion of higher longing. The poem ends with the following lines:

> A damsel with a dulcimer
> In a vision once I saw;
> It was an Abyssinian maid,
> And on her dulcimer she played,
> Singing of Mount Aborah.
> Could I revive within me
> Her symphony and song,
> To such a deep delight 'twould win me,
> That with music loud and long,
> I would build that dome in air,
> That sunny dome! those caves of ice!
> And all who heard should see them there,
> And all should cry, Beware! Beware!
> His flashing eyes, his floating hair!
> Weave a circle round him thrice,
> And close your eyes with holy dread,
> For he on honey-dew hath fed,
> And drunk the milk of Paradise.

Reason plays almost no part in this poem. Its charm lies in the imagery, and in the sheer music of the words, which gains full momentum already with the first line: "In Xanadu did Kubla Khan." Note how mellifluously the sounds flow together. "Kubla Khan" is, in its way, a great poem—great, however, perhaps only because it calls to our longings for a state of perfection of which we can only dream. And what kind of perfection? Well, none, really, if you analyze it. It hints at realms which, were we actually to enter them, might prove no more inspiring than a golf course.

"Kubla Khan" is one of the best examples I know of beautiful poetry that draws its inspiration primarily from the subconscious. Higher inspiration filters through the words much as sunlight filters through ocean water to dim depths. The poem is meaningful to us for the suggestion it gives of higher realms, but it lacks the stamp of highest greatness because, finally, it is hallucinatory. Great art must be rooted in true insights, not in wishful dreams. Clarity of feeling in the arts must open our hearts to truth, not to falsehood.

Coleridge was addicted to opium. The beauty he describes in his poem is, in a sense, an invitation to share his addiction. It offers us, at the last, a dead end.

Contrast Coleridge's poem with any of Shakespeare's song lyrics. Often these, too, are not logical. They, like "Kubla Khan," are verbal music, and as such weave themselves almost effortlessly into beautiful melodies. Their outstanding feature, however, is that, in some inexplicable way, they uplift the mind.

Hark! hark! the lark at heaven's gate sings,
  And Phoebus 'gins arise,
His steeds to water at those springs
  On chalic'd flowers that lies;
And winking Mary-buds begin
  To ope their golden eyes;
With everything that pretty is,
  My lady sweet, arise:
    Arise, arise.

The words aren't even perfectly grammatical. And who cares? There is a feeling in the poem that lifts us soaring in delight. Reading or listening to Shakespeare, one finds a subtle influence working on the mind that expands our spirits, our understanding and acceptance of life—positive attitudes all, that leave us refreshed and purified even if we don't always understand what the words say. The influence in Shakespeare, far more so than in most artists, springs from what might be called the *superconscious.*

There are, indeed, three states of consciousness accessible to man: not only conscious and subconscious, but also (though little recognized) superconscious. From superconsciousness, primarily, comes perfect clarity: a clarity of feeling as well as of reason.

Were I to discuss the superconscious at length, I would digress from the subject of this book. I've written an entire book titled, *Superconsciousness,* which is available in many bookstores.* For present purposes, however, let me limit the discussion to

---

* *Superconsciousness: A Guide to Meditation* (New York: Warner Books, 1996).

some of the *effects* of superconscious, as opposed to subconscious, inspiration in the arts.

Both superconscious and subconscious inspiration are unitive, not analytical. The perception of unity that comes with superconsciousness, however, doesn't confound analysis: It simply transcends it. If submitted to reason, it can withstand all challenges. It differs from conscious awareness only in that it brings the different aspects of perception harmoniously together.

Subconscious perception, on the other hand, confounds analysis altogether. It is a ship without a rudder, drifting toward any point of the compass that the ocean currents happen to take it. It is a thing of whims, and not rooted in true perception.

Superconsciously inspired art lifts one expansively into complete acceptance of life. Subconsciously inspired art, on the contrary, inspires an inward withdrawal, a cutting off of our awareness of objective reality. It centers our perceptions in ourselves, in our private dreamworld. Subconscious art is contractive, and ultimately, therefore, delusive.

The signs of great art are an expansive sense of oneness with all life, with all humanity, with all reality. Art that is, above all, clear on a feeling level clarifies both the emotions and the intellect. What it accomplishes, above all, is help us to break down our constricting walls of egoism.

A work of art, then, is not great merely because it is skillfully executed. It is great if its message inspires us, however subtly, toward calm, intuitive feeling, and if it helps us to recognize in that feeling at least a suggestion of our own highest, spiritual potential.

CHAPTER EIGHT

# The Source of Inspiration

Art, however much alive, can only echo experience. The clearer the experience, the clearer the echo. But the echo remains a reflection, and comes most often during reflective hours. Rarely, if ever, does it come during the heat of the moment. For the source of inspiration lies, not in the event itself, but in the artist.

The response to art, similarly, is subjective. A turtle gazing at the Mona Lisa might wonder only— or so one guesses—if the painting was worth eating. It takes inspiration on the part of the viewer to recognize inspiration in a work of art, as it takes goodness to see goodness in others.

One of the beauties of artistic experience is this very mutuality. The artist exposes his soul, in a sense. He casts before the public his bag of pearls, hoping that those who retrieve them will not be the proverbial swine. It may be because of their very fear of exposing their innermost secrets, their self-doubts, their insecurity, their moral perplexity, that many artists express themselves obscurely, or hide behind a mask of bluster and a pretense of self-confidence.

On the other hand, the greater the artist, the less his inspiration will be affected by ego-consciousness. In opening his soul to others, he is not saying, "Look at *me*, Pyotr Ilyich Tchaikovsky,"

83

but rather, "This is what I have learned of truth in my life. I offer it to you in the hope that it will inspire you, as it has inspired me."

I mention Tchaikovsky specifically because, although a great composer, he also had great difficulty in transcending his personality and its many problems. When his thoughts turned inward upon his ego, the music he wrote was pervaded by a moody quality; it was pessimistic and self-pitying. When he was able to absorb himself in a larger inspiration, however, his music was expansive, and for that reason inspiring. Most of his music in fact reveals a mixture of both trends in himself. It is this one fact, more than any other, that excludes him from the ranks of the greatest composers.

Art also provides the artist with a priceless opportunity for introspection and self-development. It is a mirror in which he can view *himself* as he is. For the singer, for instance, a tape recording can be his most accurate critic. To hear on tape the exact tones one has produced is not only an effective way of improving one's technique, but also—if one listens with calm, impersonal feeling—a means of detecting qualities in oneself that might be improved. A painting, similarly, reflects back to the creator an objective appraisal of his own inner development.

The important thing is not to treat one's art as an idol, as something to be worshiped. If the artist sets it mentally on an altar, it will feed his ego, and may change him from a more-or-less normal human being into someone ludicrously pompous and self-important.

A work of art cannot be greater than its source of inspiration, within the artist himself. The fact that a

painter has a knack for mixing colors or for painting clever designs doesn't make him outstanding as a human being. His message is, in the final analysis, the determining factor for the true value of his art. And greatness in the arts depends, as does greatness in every human being, on an artist's ability to forget himself in the contemplation of abiding truths.

In short, the artist should try to make *himself* his own masterpiece. Only to the extent that he achieves inner clarity can whatever work he produces deserve to be called "great."

And only to the extent that he can rise above self-preoccupation can he achieve true inner clarity.

The story is told of George Fredrick Handel, when he was composing the *Messiah:* His meals, which were left outside the room where he was working, went for several days untouched. At last the person who brought his food, concerned for the composer's welfare, opened the door and peeked in. And there he found Handel weeping for sheer joy, so inspired was he by the music he was receiving.

In referring to the "Hallelujah" chorus, Handel exclaimed later, ecstatically, "I did think I did see all Heaven before me, and the great God Himself!"

Great as the *Messiah* is, it can affect people only to the extent that they themselves are open and receptive to it. In this sense, a work of art offers the public, and not only the artist himself, an opportunity for self-development. For a person cannot fully appreciate a work of art unless he, too, forgets himself in his attunement with the artist's inspiration. A great work of art is an opportunity for us all to ennoble ourselves in silent communion with greatness.

A mediocre work, on the other hand, is an opportunity to spurn mediocrity in ourselves. Why, then, condemn such a work? We should be grateful to it, rather, for it gives us an opportunity to see whether there is not something in ourselves, too, that requires improvement. To dislike or condemn anything, as opposed to recognizing impartially that it might be better than it is, is a sign of some character flaw in ourselves.

Critics, again, who devote their time and energy to condemning the works of others fail to realize that by concentrating on mediocrity they nourish mediocrity in themselves. For this simple reason it is rare for a critic to produce great works of art himself.

Can a case be made, then, for finding inspiration in a work of art even if the artist himself was not inspired? Yes, certainly!

The great Indian mystic, Sri Ramakrishna, had his first experience of ecstasy when, as a young man, he was watching a flock of geese fly against the background of a grey cloud. The beauty of the scene moved him so deeply that he lost all sense of outer reality, and his mind soared into a heaven of inner bliss.

Consider, then, this point: Were the geese conscious of the effect the scene was producing on the young man below? It seems safe to assume they were not.

Again, was there some ecstasy-inducing influence in the scene itself? Would it have uplifted anyone else who observed it? One assumes, again, that others did see it, yet one reads of no one else who was similarly inspired by the sight.

A friend of mine, herself a musician, once attended a concert given in a national park by a young violinist of distinctly unprofessional skill. This friend had entered the park that day fairly singing with inner bliss—with that special feeling of upliftment which many people, I suppose, experience at some time in their lives, but alas too rarely!

"Wasn't that music heavenly!" she exclaimed to her companions as they were leaving afterward.

"Heavenly?" they exclaimed in astonishment. "Why, that boy wasn't even playing in tune!"

How had it happened that this woman, who was perfectly capable of distinguishing a good performance from a bad one, was so deeply moved by such an obviously mediocre performance? The answer is clear: She had projected her own inner feelings onto the music. She told me that she found herself doing that, no matter where she looked that day.

One can, then, find inspiration in a work of art that, itself, lacks inspiration. But in this case the artist himself deserves none of the credit. The source of inspiration lies in the viewer, or in the listener, who might have been just as inspired while gazing at a pebble, or a tree.

Much art, and much art appreciation also, is a sham. Artists challenge people to "understand" what defies all understanding. And people glance sideways to see if it is safe to respond as others think they ought to.

Picasso once submitted as his own work a canvas that had, in fact, been "painted" by a monkey. This work received fulsome praise from his "discerning" public. At the peak of its popularity,

Picasso gleefully announced its actual origin. Needless to say, everyone was mortified. (People's need for self-esteem being what it is, however, I wonder whether many viewers didn't hasten to redeem their pride by marveling that a mere monkey had been able to create such a true work of art. I suspect, too, that Picasso many times in his life delighted in tweaking his public's collective nose.)

I don't suppose that monkey became a deeper and finer monkey as a result of its colored scribbles. Even in the case of serious artists, if their aim is not to grow, personally, through their efforts, their work might as well be placed low on the scale of artistic importance: comparable, perhaps, to that of scattering pieces of broken glass on the ground. The fragments may actually form a pretty pattern, but they will do so only accidentally. The pattern will hold no message, no meaning beyond what anyone viewing it chooses to see in it.

All things being equal, the inspiration of a work of art must come primarily from the artist himself.

Let us consider once again Handel's *Messiah*.

Like most music lovers in the West, I have attended many performances of the *Messiah* over the years, and have listened to it many more times on recordings. As has surely been the experience of many listeners, there have been times when I was moved to tears through the joy I felt in the music.

Here, however, is a point to ponder: Could my joy in that music ever equal Handel's, who stood, arms extended in rapture, at the very source of its inspiration? I very much doubt it. If, indeed, any listener's inspiration were to equal his, it would have to have come independently of the music itself.

For all artistic creation is like flowing water: Its flow is downhill. Whatever point it reaches after its first emergence onto a mountainside can only be lower than that initial point. *Artistic expression is filtered inspiration.*

Observe how the process works:

First, there is the filter of the artist's own understanding, of his individuality, which is to say, of the uniqueness of his being. Whatever his inspiration, moreover, he must seek to attune himself to it with as little ego-intrusion as possible, that he understand it as a truth in itself.

Second, there is the medium the artist uses, through which he must strive to capture the intensity of the inspiration he experienced. Herein he proves his skill as an artist, for it is not easy to hold onto an inspiration while struggling with the limitations of material reality. Perfection, at this stage of expression, is impossible: No one can commit exactly to mere canvas or paper anything so insubstantial as an intuition.

Third—at least in the case of music—comes the consciousness of the interpretive artists: the soloists, the conductors, the musicians. With literary works, they must pass through editors, publishers, typesetters, illustrators, and printers, all of whom place on them the stamp of their own personalities.

Sculptors and painters may not seem to have this third "filter" of presentation to deal with, but in fact the very atmosphere of the room in which their works are displayed influences the impact of their work on the public.

Composers and playwrights, however, are in the worst situation at this stage, for they are almost

wholly at the mercy of interpreters, who may succeed in turning even a joyous work into one that resembles a dirge.

Fourth in the process comes the filter of critical opinion, whether favorable or unfavorable. At this point, a work often becomes shrouded by almost impenetrable veils of misunderstanding. It must endure comparison, whether favorable or unfavorable, to the works of others, which causes people to forget altogether the artist's own, special inspiration. His work must also steer a course through the white waters of people's prior conditioning. It is all too seldom that people get to experience, or are even *able* to experience, a new work of art *in itself*.

Fifth and lastly, there is the filter of public reaction. An artist may lay bare his soul, but if the person viewing his painting or listening to his music has just eaten several hot dogs with mustard and relish and is feeling a bit queasy; or if he has a child tugging at his arm, pleading, "Daddy, c'm on, I wanna go home!"; or if, glancing at the work, he thinks, "Impressionists—bah!" without giving this particular impressionist an opportunity to tell his own story: What chance has the poor artist for a fair appraisal?

Considering all these filters for the artist's inspiration, each of them unavoidable, think how great that inspiration itself needs to be if it is to preserve even a glimmer of its original blaze by the time it emerges into the harsh daylight of public appraisal.

This, too, surely, is why so many artists offer mere veneer as a substitute for solid substance, and claim that this veneer says it all.

I remember a piece of sculpture at an exhibition years ago that bore the grandiose title, "Fourth Allegory." The sculptor himself admitted to me frankly—indeed, proudly—that his work had no meaning. When I asked him why, in that case, he had called it an allegory, he replied, "Yes, it may deserve that criticism." And he wanted the public to believe that this was already his fourth work on the same non-existent theme!

Inspiration is not a beautiful sunset waiting to be reproduced exactly as the painter sees it. It is not a bird's song, captured on a recording by the hopeful composer. Certain modern symphony music has tried to convey the impression of city traffic by duplicating the sounds of car horns and motors. Where is the artistry in that? The composer is asking his listeners to provide the "art" themselves, by their personal reaction to the noise. What he ought to do, as a composer, is express in music the feelings he himself has in reaction to the noise—not the noise itself, but the agitation and nervousness, or the determination to affirm inner peace in the face of cacophony, or simply amusement at people's willingness to live in such surroundings: anything that will show us that we are dealing with a work of art, an *echo* of experience, and not merely with the sensations that are supposed to produce that experience. The artist must say, "This is what I felt as I was listening to those car horns," and not, "Here is what I heard: See what *you* make of it."

The artist must realize, in short, the truth of what Yogananda said, "Conditions are always neutral. They seem happy or sad, according to the attitude of the mind."

Art—to reemphasize this point—can only *echo* experience. Art is not meaningful if it merely reproduces whatever induced that experience in the first place.

Even photography, which seems only to record what the photographer sees, is creatively selective. The angle of vision, the focus, and the photographer's abstraction, out of a particular scene, of that particular point which awakened his own interest— in these aspects and in many more, photography is an art form. It can suggest to the viewer an experience that the viewer himself might not have had, had he been alone, facing the same subject.

I sometimes wonder whether even more than the artist's reaction is not involved. Even great physicists have been voicing more and more the suspicion that, underlying the universe, and even creating it, is consciousness. Sir James Jeans, one of this century's foremost physicists, said that everything looks suspiciously as though it had been created out of "mind stuff."

What if the flower the photographer is photographing be capable of actually responding to the feelings he projects toward it? Might there be, in his subsequent print, some vibration of the flower's own appreciation for his love? I say this not to convince anyone, nor even because I myself am convinced, but only as a reminder of how subtle this matter of artistic inspiration may actually be.

Perhaps those geese were in some way blessed by Ramakrishna's ecstasy. Perhaps Monet's garden at Givenchy became the more beautiful for his appreciation of it.

If these things be even remotely possible, we have an even deeper reason for viewing art as a responsibility—not only for personal growth and inner development, and not only for giving inspiration to others, but also as a means of making the world itself, *in* itself, a more beautiful and harmonious place to live in.

I'll step further out on a limb, and suggest that by the art we produce, and also by the way we view all things, we attract to ourselves aspects of consciousness—higher entities, perhaps?—that bring blessings, or, on the other hand, lower entities that can curse us with suffering and disharmony.

I don't want to leave the poor, laboring artist with the feeling that his burden of responsibility is intolerable. Let me therefore close this chapter by restating how important it is that he not take himself too seriously.

I will step lightly into an arena where I find myself as much out of place as a deaf-mute among troubadours. For I'm constitutionally incapable of being a fan of the Beatles. The beat they heard was not my own. Nevertheless, they quite won my heart when, at the outset of their career, one of them answered the question, "Do you think your music will live?" by exclaiming, "I don't see why it should!" It was their very relaxation about themselves that made their music so popular.

# Secrets of Creativity

Our experiences should be lived for themselves; they should not have to be validated by the experiences of others. Art, too, should be judged for itself, and not by reference to the works of others. The more deeply we learn "to see infinity in a grain of sand," the better we shall be able to understand from that grain whatever it has to teach us. Wisdom comes not by counting an infinite number of grains, but by probing the mystery of one single grain, even, to its final essence.

Realistically, of course, comparisons cannot be ignored altogether. They simply reflect the way the conscious mind works. Only in superconsciousness will they be forgotten completely.

Realistically, then, what we must do is try not to define art *only* in terms of technique, of outward form, and of adherence to objective norms. The conscious mind will always look for pigeonholes in which to store things, but one should make a conscious effort to broaden his perspective. The neatest filing system can be no substitute for the information it categorizes. The most precise definition of a tree cannot substitute for planting and growing a live tree. Understanding never comes by definition: It comes by experience.

I wonder if I shocked a reporter who was sent by an Italian magazine a few months ago to interview me about my music. At one point during the interview she asked, "What is your favorite music?"

"My own," I replied without thinking. I surprised myself a little by that answer. But I was being sincere. The music I write expresses the vibrations of my own being. It says, as nearly as anything can, who I am and what my inner feelings are about life.

Had she asked me, on the other hand, "What do you consider the *best* musical compositions?" my answer would have been very different. In fact, I'm not sure I could have answered her at all. There have been so many great and wonderful works, each of them inspiring in its own way. Sometimes a simple song can be more moving than an entire symphony. Probably, in the end, I'd have answered her like this: "I consider the greatest works to be those which have been written as offerings of love to God, and which God has inspired in return."

As for my own music, I really have no idea how it compares with anyone else's, any more than I think it matters how I, personally, compare to other people. I am myself, simply, as everyone else is simply himself or herself. Each of us is, in some very special way, unique.

It is unfair for anyone, in his true self, to have to stand comparison to others. There is in each of us a special song to be sung. None of us is more important, or less so, than any other. Our simple duty is to find our unique song deep within us, and to sing it to perfection. That perfection will come only when we have learned to sing our own soul-song to God, offering back to Him the inspiration of *His* love.

I'm aware that there must be millions of people who know more about music than I do. I frequently have to ask others for advice on matters of form. Nor am I nearly so quick as even some of my own friends when it comes to recognizing a melodic variation, or a chord inversion. In fact, I'm sometimes appalled at the extent of my ignorance in a field in which I strive sincerely to do my very best.

"Do you *really* like it?" I sometimes ask people, wondering to myself, "How can you possibly?"

And yet, when I turn the question around and ask myself, "Do I, myself, like it?" my invariable reply is, "I *love* it!" It's what I heard, during some wonderful moment of upliftment. It is my way of saying "thank you" to the universe for giving me that inspiration. Often, while writing a piece of music, I've wept tears of sheer joy and gratitude.

But if I'm asked to compare what I do with music that I know to be great, all I can say is, "This is mine, and that is theirs." As the expression goes, apples can't be compared with oranges.

One of the secrets of creativity is to live in the moment, and in the work of the moment. A work of art must be a projection outward from one's center within. And the inspiration behind it arises from an act of communion between one's own center and the center, so to speak, of the subject he is describing. If he is painting a tree, he should feel in his heart a connection with the psychic center of that tree. Even if his subject is something abstract, he can feel its heart intuitively, in its essence.

I realize that I am being abstruse, but I don't know how to express this thought more graphically. And I know from experience that what I am stating

is true. The artist needs to perceive inspiration itself as having a center. He must then try to communicate with that center from a central point in his own heart.

Every time you finish an artistic work, wipe your mental slate clean, as though you'd never done anything at all. Indeed, the more you can rid yourself of the thought of yourself as the creator, the better your art will be. Think of yourself as simply a channel for whatever is being expressed through you, After finishing a work, then, cleanse your heart of any lingering thought that that work is yours.

Welcome every inspiration as it comes, as the unique moment in time that it truly is. No two inspirations, and no two moments in eternity, are identical. If two works resemble one another too closely, consider whether you have not plagiarized yourself.

*Faith* is necessary to creativity. Have faith that inspiration must and *will* come to you, if you ask for it sincerely, and with full, joyous expectation. It *will* come to you, if your invitation to it is tendered with deep trust in a will higher than your own.

Paramhansa Yogananda was once asked, "Is it possible to attract inspiration at will?"

"Most certainly!" he replied. "Let me show you. Take down this poem."

Though busy at the time, he stopped briefly and focused his attention inwardly.

"Father," he dictated, "when I was blind I found not a door which led to Thee, but now that Thou hast opened my eyes, I find doors everywhere: through the hearts of flowers, through the voice of friendship, through sweet memories of all lovely

experiences. Every gust of my prayer opens an unentered door in the vast temple of Thy presence."

This poem appeared later in a book he titled, *Whispers from Eternity*. A reviewer praised the book, then added, "There's one of these poems that I can't resist quoting." And this was the poem he selected.

How many artists have endured long periods when, try as they would, they felt no inspiration. Perhaps it was their very fear of losing inspiration that undermined their faith, and thereby paralyzed their will power.

Will power is the key to awakening energy. Yogananda used to say, "The greater the will, the greater the flow of energy." We can apply this principle to the task of keeping the body in good health and healing our illnesses. We can apply it also to drawing inspiration at will. For energy in the body, like electricity in a copper wire, generates a magnetic field, and that magnetism attracts to itself its own affinities, and repels that for which it has no affinity. A strong thought, when directed by will power, can generate the magnetism necessary to attract solutions to any problem one faces. That magnetism can attract true friends, hoped-for opportunities, and success in any undertaking.

Will power, combined with faith, directs a clear, unwavering flow of energy. Doubt, on the other hand, interferes with that flow, weakening it, for it creates vortices of indecision. "Is this really what I want to do?" people ask themselves even as they strive for achievement. "Am I capable of doing it? What if I fail? What if better ways exist for approaching this problem? Am I sure this way is the best?"

Energy vortices of this nature interrupt the flow of energy, and disturb the flow of inspiration.

I mentioned earlier the importance of seeking superconscious, rather than merely subconscious, inspiration. Superconscious inspiration functions in a way quite different from the rational approach of the conscious mind, or the irrational meandering of the subconscious. The conscious mind, which understands things by analyzing and comparing them, is naturally *problem-oriented*. Superconscious awareness, on the other hand, is *solution-oriented*. The more problem-conscious we are, the less it is possible for us to function superconsciously.

Don't ask yourself, then, as you set out to create an artistic work, "What do I do about this problem?" You might go in circles indefinitely with that thought. Ask your higher Self, rather, "I have this need to address. Give me a solution." The more you think in terms of solutions, and seek them with faith, the more certain you will be of doing the right thing. But if you tell yourself, "I must be realistic, and I know I have problems, so let me think what to do about them," the consciousness of those problems will develop a magnetism of its own. All you will see is more problems.

The clearer your idea as to the kind of inspiration you need, the greater the likelihood that your answers will appear in your mind as it were full-blown.

One day I wanted a melody to go with a group of color slides I'd taken of Pompeii, Italy. Instead of worrying away at the keyboard, or muttering darkly to myself, "Pompeii, Pompeii!" I asked myself, "What do I want this melody to express?"

Well, it had first of all to address the tragedy of Pompeii, a city that was destroyed two thousand years ago, when Vesuvius erupted. But after all, I reminded myself, two thousand years is a long time. That tragedy has by now lost its immediacy. The melody can't be *too* tragic.

Again, I thought, the melody should convey a hint of the consciousness of the sin that must have caused that city to draw that punishment. And yet, again, the sin can't weigh so very heavily after all these years. Surely its karmic cloud has drifted away by now, dispersed by the crosscurrents of other karmic influences. Indeed, I'd felt no heaviness in the atmosphere of the city comparable to what I felt, for example, in Cambodia some years before its devastation. Here was tragedy, then, but a tragedy ancient and now dimmed, its remnants covered over, so to speak, by the moss of time.

With these thoughts fixed clearly in my mind, I offered that image up to superconsciousness with the prayer, "Give me a melody that says these things." Instantly the melody came, and it expressed everything I'd hoped for.

I would print the melody here, were this book intended only for musicians. Because most people are unable to read music notation, I will spare them the frustration. This piece was recorded, and is available from the publisher on a cassette tape called *Mediterranean Magic*.

It is important not to be emotionally involved, even though the feelings are awake, and perhaps intensely so, with the inspiration you are expressing. (Even tears don't necessarily signify emotional *involvement*.) In the case of my melody, "Pompeii,"

its essence of course concerned a degree of detachment anyway, since the event it described occurred long ago. But the principle of non-attachment would have been as important had I been describing some recent tragedy such as the bombing of a friend's home. The calmer my perception, the more clearly it would be able to depict that occurrence in the context of its inner meaning.

An emotion is not best expressed during the heat of the moment. Later on, when the heart is calm and relatively detached, and when we are able to view the episode as it were from above, we can communicate it more effectively to others. For when communicating, the realities of others have to be taken into account also. At the peak of emotional intensity, or even of calm, intuitive inspiration, the focus is not on communication, but on absorption.

A warrior cannot fight effectively for his life* while at the same time composing poetry on the virtue of courage in battle. An artist cannot wholly immerse himself in the beauty of a sunset while hauling out his easel, setting up his canvas, and mixing paints. And a lover cannot fully convince his beloved of his love if, one second after kissing her, he cries out, "Wait a second! 'Kiss . . . kiss': Hey, gimme a good rhyme for 'kiss.'"

The best time for creativity, then, comes after, and not during, the moment of revelation. One may say, indeed, that art is *remembered* experience. The natural time for it comes afterward, during moments of reflective calm. Very rarely is the moment for artistic expression that of the actual experience which

---

*Swashbuckling movies to the contrary notwithstanding!

inspired it. When it is, it can only mean that the artist has achieved such a depth of inner calmness that he is able to distance himself from his experience even during its occurrence. For without inner detachment, there cannot be inner clarity.

Creative artists would like, of course, to express their creativity during the "heat" of inspiration. The higher that inspiration, however, the more silent the mind becomes. And the more silent the mind, the stiller—of necessity—the pen or the brush. Even Handel, while composing the *Messiah,* had to hold the divine beauty he perceived at arm's length while he wrote. Otherwise, he could not have composed his oratorio.

Handel may be compared, in this respect, to the *bodhisattva.* A *bodhisattva* is a spiritual aspirant who, on reaching the state where his soul is ready to plunge into the ocean of infinity, suspends that immersion and turns back to tell others of the glory that awaits them in their eternal Self.

The mind of the artist is, as I have already indicated, a filter. It is the medium through which his inspiration pours, much as sunlight pours through the panes of a stained-glass window. Because the mind cannot but act as filter, what it expresses inevitably conditions what it receives, even as the colored panes of glass in a window change to some extent the rays of sunlight by admitting only one band of their color.

It is important, then, that the artist keep his mental filter as clear as possible. For even with seemingly perfect inner clarity, his art will represent a descent from subtle realms to one that is relatively

gross. Art is, perforce, in this sense, a limited expression, and cannot be otherwise.

Art, to reiterate, is essentially a reflection upon experience. It is not only remembered experience: Rather, it is, or should be, the memory of that experience *held up to the calmness within.*

I had a curious experience while writing another piece of music called "Deirdre's Sorrows." The well-known Irish harpist, Derek Bell, had graciously suggested that he'd like to record an album of my music. One piece for the album was based on the ancient Irish legend of Deirdre.

Deirdre's life is a tragic tale of betrayal, death, and self-immolation. I had to describe musically her intense emotions, which form the basis of that story. My first problem was that I hadn't experienced that sort of tragedy, myself. What I did, then, was take her story into the stillness of meditation. There I asked Deirdre herself to sing her tragedy to me.

I knew, of course, that she was only a legend, but legends, too, have a certain reality. I tried to tune in to the center of that reality, as though Deirdre had been an actual person and could sing to me of her life.

It wasn't my purpose to experience her emotions personally. It wouldn't have helped the music for me to feel her anguish in my own heart. If the music were to come out turbulent, the listener, too, would be whirled off into clouds of confusion. The music had to convey, in other words, not torment and suffering, but the clarity that comes after release from torment and suffering.

I actually heard a woman's voice in my mind, singing its melody and later speaking the words. Was

it imaginary? Well, how could it be anything else? But the imagination was focused and uplifted, and thereby drew a superconscious reply.

This experience was, for me, an important and instructive lesson. For I'd seen no benefit in upsetting people with the music. My hope, then, had been to uplift and enlighten them. And I discovered that, by viewing tragedy itself from a center of inner calmness, its intense pain can actually be transmuted and become, in a strange but wonderful sense, joyful.

Tragedy is a facet of the ever turning, ever changing jewel of life. If we hope to attain wisdom, we must remain untouched in our hearts by even our cruelest experiences. The indwelling Self, so says India's great scripture the Bhagavad Gita, cannot be born, and cannot die. Fire cannot burn it, nor water drown it. Swords cannot cut it, nor wind desiccate it and blow it away. Death itself is only a dream: It affects the body, but it need not ever affect the mind.

The suffering expressed in "Deirdre's Sorrows" is real, and mounts in intensity until it reaches a climax in Deirdre's suicide on the corpse of her beloved. Yet the music manages at the same time to express a healing energy. It is cathartic, for it purifies the listener, lifting him above his own personal tragedies into calm, expansive acceptance of the Eternally Inevitable.

Such, at least, was my intention. How successful I was in my attempt is for the listener to say. For myself, I can say that I actually found joy and inspiration in the writing of this song.[*]

[*]The album appeared under the name, *The Mystic Harp.*

There is no getting around it: If an artist wants to reach people on any level, he must experience that level first in himself. He can't expect to carry the torch of inspiration through the rain of diluting influences if the torch itself is only a sputtering match.

The artist must, in other words, be very clear about what he himself is trying to express. Vague impressions will simply translate themselves into even vaguer impressions.

Many an artist has given voice to his feelings in words something like these: "Well, man, I was standing up there on that mountaintop—you know what I mean?—and suddenly it hit me, like, you know, things just don't have to be the way they are." No? Please tell me, how *are* things, that they need changing? Why don't they have to be as they are? And how else might they be?

An artist doesn't have to have rational answers to these questions. After all, he isn't supposed to write a philosophical treatise when he sits down to write a poem or a sonata. He might even make some such statement as the one above, incoherent as it seems when verbalized, with a perfectly clear conception of what he is really trying to say. It may simply be that, for him, his clarity comes when he's standing before a canvas, or thinking in terms of melodies and chord progressions. All this is quite possible, though certainly by his words alone he gives no hint that such is the case. Clarity on *some* level of awareness, however, is essential.

I remember a time several years ago, when I was composing an oratorio titled, *Christ Lives.* During that time, music was so much my focus of

expression that I had difficulty tuning into the patterns of speech. One evening I hosted a dinner party, which had been previously scheduled. A woman friend addressed me at the table, and I found myself staring at her in a kind of bewilderment for a few moments before replying. Later she remarked to me that she'd had the feeling I was wondering, "Now, is she a B-flat?"

Music is its own language. It cannot easily be translated into words. Perhaps I'd have answered my friend better by singing to her!

That is why the play, and later the movie, *Amadeus,* was so absurdly inadequate in its portrayal of Mozart. For even if young Mozart did use coarse language (and if he did, I'm inclined to think it was only in naive reaction to intellectuals who dismissed his music as too innocent), words were not his true medium of self-expression. Speech was, for him, almost an alien tongue, with all the frustration that trying to speak in a foreign language can induce.

Painting and sculpture, too, are languages. Who can explain why a certain line conveys a sense of happiness, and another, a sense of loneliness, sorrow, or despair? They simply do. Who that has ever entered into deep attunement with the visual arts can deny that such is the case? But who can explain why it is so? Any artist so uninspired as to think, "Eureka! I have the formula!" would find that no amount of effort to reproduce that identical linear sweep could ever result in an identical effect.

Look at the movies put out by Disney Studios since the death of Walt Disney himself. Walt Disney was, in his own way, a great artist. He labored patiently and sensitively for many years to produce

what were works of art in their own right. He had to discover for himself the rules of his art. What he passed on to his successors was an impressive legacy of creative fantasy, and of techniques for evoking that fantasy. It is easy to see their skillful use of his techniques in the films that have come out from Disney Studios since that time. Yet, somehow, his inspiration is lacking.

The inspiration in a work of art is vibrational, primarily. Even if its outer shell were to be reproduced exactly, its inner essence would be lost. It is as if art were imbued with a life of its own.

I remember when I saw the Taj Mahal in India for the first time. How uplifted I felt! Its sheer size, of course, must account for some of the awe one feels on beholding it. But there is more to it than that. How breathtaking the sight, as one stands before it! No model, no mere photograph could begin to convey that impression.

Go to Delphi, in Greece, if ever you get the chance. Stand in what today are only ruins. *Feel* the place; don't merely stare at it. I can't believe that you won't be moved by the experience.

People riding the crest of a fad may paint blue paintings for the simple reason that "blues are *in,* these days." They may compose dissonant symphonies because dissonances are considered "avant-garde."

I remember seeing a picture window in San Francisco that looked out onto a street that was littered with newspapers and lined with unattractive houses. Why, I marveled, had the architect thought to put in a picture window? And then I remembered: Picture windows were "in" just then. It didn't matter

107

that the reason they were "in" was that they'd been featured first in country homes with beautiful views. "In," as far as this San Francisco architect was concerned, was "in."

Artists going at their work in this kind of spirit will never produce anything really worthwhile.

Whatever a person wants to express, regardless of his medium of expression, it can be stated successfully only if he is very clear in himself as to what he wants to say, why he wants to say it, and what is intrinsically *true* about this particular statement.

An interesting phenomenon of verbal communication is the fact that one of the best ways of getting a clear answer to a question is to state the question clearly. A well-stated question is already halfway to its own solution. In whatever form of art you are engaged, you will find, similarly, that the principal obstacle to creativity is not fatigue, nor even a feeling of being dull. The obstacle is being unclear in yourself as to what feeling you would like to express.

Once this clarity comes, inspiration flows.

Clarity begins with asking the right questions. It comes with knowing exactly what the problem is, and then offering that problem up into the creative flow, in the full expectation of receiving a solution.

Clarity comes, next, from one-pointed concentration. Nothing great can be accomplished in the arts without complete attention, any more than a camera will take clear pictures if the lens is out of focus.

If, then, an artist wants to improve his work, he will do well to devote himself not only to art itself, but to developing his own powers of concentration, and his own inner clarity.

We arrive, now, at the ultimate secret of creativity: *High inspiration in the arts is, and must be recognized as, a descent into the mind from higher levels of consciousness.*

# Clarity Comes with Expanded Awareness

A lady was once listening to someone reading the lusty "Miller's Tale" from Chaucer's *Canterbury Tales,* in the original Middle English.

"Why, its beautiful!" she cried. "I wish I could understand it."

The reader pulled out another volume from the bookcase beside him, and began reading to her a translation into Modern English of the same story. Halfway through the reading the lady cried out, "Stop! Please stop. Oh, I wish I hadn't understood it!"

Clarity is important to any undertaking. Sometimes, however, it can be embarrassing. Many a modern painting that is now displayed proudly in the living room would be rushed up to the attic, were it understood.

More often, however, any attempt to clarify the meaning of a work of art would simply reveal that it was quite meaningless.

I can remember times when I've thought that what I was writing was going beautifully. But as I worked to make it simpler and clearer, I discovered that, stripped to its essence, it revealed itself as sheer nonsense.

It is as difficult to face lack of clarity in one's work as it is to face it in oneself. The one is a reflection of the other. It is important in any case, however, to "face the music." We'll have to do so, sooner or later, so why not sooner? Why not, in other words, get the operation over with?

We are like chicks facing the task of breaking out of our little shells of ego—out of our habitual ways of looking at and of doing things—out of our social conditioning. How can we experience clarity unless we willingly face things as they are, and stop affirming that they are exactly as we wish they were?

Socrates believed that if everyone could be led by calm, impersonal discussion to the clear truth of any matter, humanity would voluntarily forsake evil. For, as he said, true happiness can be found only in virtue. The problem with his thesis is that people generally don't want to face the truth. And although everyone wants to be happy, few people are willing to forsake that which makes them unhappy. Socrates himself was condemned to death by the Athens elders, who preferred their own ignorance (and unhappiness) to his supreme sanity. Death, for him, however, was no condemnation, for he had attained that truth which, as Jesus Christ put it, makes one free.

There are two directions for creativity to flow. One of them is contractive; the other, expansive. Contractiveness focuses on likes and dislikes, one's own and other people's. Expansiveness focuses on what is right and true.

Contractiveness is unsympathetic to any point of view but its own. Expansiveness listens to other points of view, and tries to understand them.

Contractiveness lowers our consciousness, plunging it into a world of emotions and egoic attachments. Expansiveness lifts our consciousness, helping us to spread mental wings and soar up through skies of inner freedom.

Feeling, once awakened, must be directed upward toward the brain and toward higher perceptions. If we allow it to flow downward into sense-attachment, it ends up reinforcing the very mental enclosure we thought, in the first exuberance of our emotion, we had escaped.

The vision that people of clear insight achieve is always expansive. It hints at ever broadening vistas.

A merely gifted composer, but not a wise one, seeking to capture in music the sight of a moonrise, will likely dwell on the uniqueness of that occasion. If he can find a way to demonstrate his own sensitivity to the event, he will not neglect the opportunity. It probably won't occur to him to see the moonrise as symbolic of abstract principles such as hope or purity, or of universal realities such as the whirling of stars and galaxies through infinite space.

A composer, on the other hand, who has achieved that vision which one intuitively equates with greatness will behold the moonrise as intrinsic to the broader drama of space, time, and existence. If he depicts his personal reaction to the event, he will seek instinctively to universalize it as the reaction of mankind. Probably, however, he won't even be aware of himself, for he will lose ego-awareness in contemplating the calm scene before him.

Art that is crystal clear expands naturally beyond the limits of the particular to the limitlessness of the universal. At the same time, it keeps a clear focus on

whatever seems relevant in the particular, scanning it in its finest details for windows onto infinity. The expansive quality of such art is reflected in these glorious lines from "Hymn to Dawn," in the *Rig Veda:*

> Last of innumerable dawns gone by,
> First of endless dawns still to come.

It is reflected in William Blake's "Auguries of Innocence," in what are his most famous lines:

> To see a World in a Grain of Sand
> And a Heaven in a Wild Flower,
> Hold Infinity in the palm of your hand
> And Eternity in an hour.

Great art is always, whether deliberately or by some sure instinct, a living embodiment of the principle of expansiveness for the simple reason that expansiveness is instinctive to the quality of greatness in human beings. Greatness, indeed, *means* greater-than-normal perception of reality. It means an awareness of the whole even during concentration on the part, as opposed to smallness in human nature, which thinks only of the part even when it is confronted with the whole.

The less a work of art expresses the crystal clarity of intuition, the more it becomes directed toward the particular. And the more it expresses crystal clarity, the more its vision is directed expansively from the particular to the universal.

One reason that so many works of art fail to express greatness is that artists are deluded by the thought that they create anything. The greater a work of art, the less it is a product of the mind. Great

artists have often remarked, as Handel did after writing the *Messiah,* that it was as if inspiration came to them from some higher source: It didn't seem to originate in their minds. Brahms stated that mind-born inspiration belongs to a lower class of creativity.

I call that higher source, God. Some people, conditioned by a variety of influences, resist using that word. If you prefer, then, call that source your higher Self. Call it superconsciousness. Call it what you like. The fact remains that we are all part of an infinite reality, which includes not only stars and galaxies but some awareness far greater than our own. The more we open our limited consciousness to infinite possibilities, the more our every creative work can become that sort of art which mankind has always recognized as great.

# Self-realization Through Art

I once went with a group of friends to see the movie of Laurence Olivier in his great performance of Shakespeare's play, *King Henry the Fifth.* As we were leaving afterward, one of our group exclaimed, "I never realized Henry V was such a great orator!"

I reminded her with a smile that, after all, Shakespeare was pretty good as a speechwriter.

Hearing me, she shook her head a little in surprise; then laughed self-deprecatingly. "Of course you're right!" she replied. "I was so caught up in the mood of his play that I forgot all about Shakespeare."

What greater compliment could be given an artist than to forget him so completely in the contemplation of his work? Shakespeare could only have achieved his stature in the literature of the ages by suspending self-consciousness and immersing himself wholly in the dramas he created.

A problem facing every artist, though few of them recognize it as such, is how to abandon self-consciousness to a greater awareness. The true goal of art is, to paraphrase William Blake, "to see one's Self in a grain of sand, and one's eternal existence in an hourglass." It is to realize oneself in one's greater Self—to know one's identity with humanity, with

the clouds, the setting sun, the wind's whispers on a grassy hilltop, the distant stars.

Self-realization means, ultimately, to know our identity with the great Source of all that is. Call it God and we but name the final secret of our own being. Self-realization is the highest goal of artistic expression. Few cognize it as such, but those who come closest to this understanding are the ones most likely to achieve greatness in their art. Truly great art is always, I seriously believe, that which is offered on the altar of that ideal—even as minor art is always that which is offered up in worship of the ego.

When you behold a countryside, your experience of it goes beyond what your eyes see. It includes, subliminally at least, your inner reaction to the scene. The artist who paints it may depict a neat landscape with clipped hedges, patchwork-quilt fields, and fleecy clouds roaming the sky like grazing sheep. Later on, he may insist that his painting depicts exactly what he saw. But even if it seems completely realistic, it will be in some way also a very personal statement, a revelation of his personal outlook on life.

Perhaps his very attempt at realism suggests a certain rigidity of nature, or a literal mind which defines itself as no-nonsense, down-to-earth, practical.

If the painting contains an exaggerated sense of neatness, it may suggest nostalgia for some ideal way of life in an era long past.

Greater emphasis on sweeping lines in the land will suggest rhythm: the rhythms of life, perhaps, or of the emotions; rhythms of happiness or rhythms

of grief. Already, in these cases, the painting will have moved beyond the simple demands of realism.

Were those clipped hedges to be given heavier emphasis, the painting would suggest a feeling of enclosure—as though the artist felt himself living in a prison of emotions.

Were there a little more emphasis on the patch-work-quilt effect of the fields, the painting would, depending on the hues, be a statement either of indecisiveness or of delight in life's variety.

Softened contrasts might convey an over-all sense of tranquillity.

Softened clouds, again, might suggest faith in the workings of destiny: in divine protection, perhaps, or in heaven's blessings.

Just as an artist cannot but project himself onto whatever he paints, so the members of his public will also read into his painting their personal outlook on life. One viewer may see in those softened clouds a suggestion of divine protection, whereas the artist himself may in fact have been reliving childhood memories and thoughts of cotton candy.

The best way to understand a painting is to sense its *vibrations*. Deep understanding is never the result of analysis alone. It comes, rather, when we back away from it a little, mentally, and feel the reaction of our hearts. It comes by setting aside for the time being our own personalities, our prejudices and pre-conceptions. It comes by tuning into the *consciousness* behind the painting.

Paramhansa Yogananda wrote, in the introduction to his commentaries on the *Rubaiyat* of Omar Khayyam: "One day, as I was deeply concentrated on the pages of Omar Khayyam's *Rubaiyat*, I

suddenly beheld the walls of its outer meanings crumble away. Lo! vast inner meanings opened like a golden treasure house before my gaze."

We shouldn't think of paintings only in terms of their lines, color, and symmetry. We should try to *feel* their effect on our consciousness.

I remember when I met Ernest Wood, philosopher and author of several books on Indian philosophy. He seemed to me at the time a pleasant but not particularly unusual human being. While I was driving down the freeway afterward, however, I recalled his eyes, and became aware suddenly of a joy in them that could only have come from a person of elevated consciousness. I realized, then, that our meeting had been a blessing.

Understanding, as I've said also of artistic expression, often comes after the experience, not during it. It is from that vantage point, usually, that we can gain perspective.

At Haverford College, during a class on literature, the professor asked us to describe our criteria for greatness in literature. I've always been pleased with my reply, though the professor himself only shook his head bemusedly, and gave me a flunking grade.

What I wrote was: "I've noticed that great literature seems to emit a kind of light. Homer's *Iliad*, whenever I reflect on it, seems surrounded by a blazing golden-white light, from which fact I know it to be a great work even if, intellectually, I don't see why it is held in such high esteem. And when I think of Shakespeare, I seem to see a brilliant golden-blue light, with tinges of red. I know from this fact that Shakespeare, too, was a great writer. And though I love Shakespeare, from the light I sense from these

two I think Shakespeare's stature may have been less than Homer's.

"From Chaucer I seem to sense a brownish-green light, slightly dull in hue. And I know from this fact that Chaucer, although great, was far less so than either Homer or Shakespeare.

"From most works, I sense no light at all. They remind me of the words of Jesus, 'Let the dead bury their dead,' a statement suggestive of the spiritual numbness in which most people live."

You may not see light, or even sense it, when you think of a work of art, but if you consult your heart I dare say you will feel *some* response which transcends critical analysis. Most paintings, and most art generally, produces hardly a ripple of response on this feeling level. But there are works that do. And they are the great works.

Some works of art leave us feeling inwardly joyful. Others stir in us feelings of love, or compassion. Still others suggest to us a sense of sadness or loss. These last, however, are lesser works. In the greatest works, even tragedy is sublimated in joy. Joy is the natural state of the soul.

Really to tune in to a work of art, you must, as I said, step out of the picture, personally, even as the artist should do when he paints. Hold the work up, inwardly, to your higher Self. Concentrate your perception of it at the "spiritual eye" in the forehead. After that, concentrate your perception in the heart. Don't hold any particular expectation there, but wait for whatever response comes to you.

The more faithfully you pursue this, the better at it you will become.

Most works of art emit no "light" at all. Many of them, however, convey a good feeling even so. It is a pleasure to have such paintings in the home, where they can be seen daily, or to play tapes of calming or happy music. To do so brings harmony to the home.

Music, in fact, exerts a strong influence on our consciousness. If it can influence plants to grow faster, how much greater is its potential for influencing us.

It is said of the Chinese emperors in ancient times that whenever they toured the provinces, they asked to listen to the music. They didn't look at the financial records. Nor did they inquire into the honesty of the officials. If the music was right, everything, so they believed, was as it should be. But if something was not right with the music, not only did this deficiency mean there was something wrong in those other areas of activity, but it was the music above all that needed correcting. Once that had been set right, everything else would improve also.

This story may be a simplification of the way things actually happened, but there is much in this legend on which to reflect. Indeed, truth often is made clearer in fiction than by a retelling of bare facts.

The artist, too, if he would draw the best out of his subject, might find it helpful to think of it in terms of its inherent *music*. Melody, harmony, and rhythm are present in everything we see, for what we see with our eyes is reflected light, and light is vibration even as sound is. Both are manifestations, on different octaves, of the same reality.

To draw the best out of a subject, visualize it in the "spiritual eye." Then sense what response you perceive in the heart.

There are actual centers of consciousness in the body. In Sanskrit they are called *chakras*. The *chakras* were discovered by the yogis of ancient India during meditation. They have been experienced also by many meditators in the modern world. These "*chakras*" belong to common human experience as well: Even non-meditators can relate to them, though perhaps less easily so.

Most people, for example, have experienced love as a feeling in the heart. I'm referring less, here, to the physical organ than to a center of energy in the spine just behind the physical heart. A lovesick youth may exclaim, "Oh, my heart is broken!" We can't really imagine him crying under such circumstances, "My knee is broken!"

Concentration and will power, again, are centered in the forehead between the eyebrows. That is why, when we concentrate deeply, or when we strongly will to do something, we tend to knit our eyebrows.

Most of the *chakras* (seven in number) are located in the spine. The highest two are located in the brain. The lower three *chakras* are associated with lower states of consciousness.

If a painting depicts people with distended bellies, fat hips, and a slouched sitting posture with the hips perhaps thrust forward, it suggests a lower state of consciousness. Yogis would understand that the consciousness in the painting is radiating outward from the lower spine.

If, on the other hand, a painting depicts figures with expanded chests, straight spines, and an upward gaze, it will suggest a positive, uplifted

awareness, radiating outward from the higher *chakras*.

When an artist depicts uplifted states of consciousness, he automatically selects hues that are light, or that give special emphasis to lightness in the central areas. If his consciousness moves naturally upward in his own spine, particularly toward the spiritual eye, everything he paints will reveal a hint, at least, of that upward movement.

His very view of life will embrace the thought of self-transformation. Even if his painting depicts a scene of drunken debauchery, it will do so from higher levels of awareness—a fact revealed, again, through his choice of color, or through a refinement of the lines, and almost certainly in the expressions of the people, which may even reveal their amusement at the absurdity of the scene.

Again, insight into such a painting must come from the way it affects our inner feelings, more than by a process of intellectual analysis. And, yes, it is always possible to project our subjective reactions onto a painting; that is why final judgment on a work of art must await the passage of time and the reactions of discerning art lovers, often over centuries. (Bach, for example, was all but forgotten soon after his death. It was only in the next century that Mendelssohn, a lesser but still great composer, and a gracious and generous spirit, rediscovered him.)

The higher the center of energy and consciousness in the spine, the more exalted the vision.

I was intrigued to observe the effects of this inner transformation in the paintings of Fra Angelico[*] during a visit to the monastery San Marco in

_____
[*]He is now officially named "Beato"(Beatified) Angelico. I hope

Florence, Italy. I noticed that, in his depictions of demons, he showed himself so ill-tuned to that level of consciousness that he painted their faces with expressions not very different from his angels. Fra Angelico, in his goodness of heart, could not even imagine the depravity of evil.

General gauntness in a painting may reveal a lack of heart quality; perhaps also a certain fanaticism or intolerance. Hard lines reveal will power. Soft lines reveal sensitivity of feeling.

A landscape that is painted from higher centers of consciousness may suggest, as I stated, an upward flow of energy, as if the scene were being offered up to the sky. But a landscape that is painted from the lower centers is likely to suggest a downward movement, as though its energy wanted to sink into the earth.

The clouds painted from lower consciousness may be dark. The ground, too, may look oppressed by their heavy influence.

I don't mean to say that, in order to alleviate sorrow in a painting, the artist has to show rays of light bursting downward through the clouds. That would be one way, though perhaps a bit obvious, of accomplishing this effect, but there are subtler ways of accomplishing it also. These ways might include a certain lightness in the color of the hilltops, or a rising sweep in the rock formations. The effect might by accomplished by a certain warmth of color in the valleys. No rules can be laid down for this sort of

readers will not be offended by my use of "Fra" (Brother). Most people still know him by this appellation, and I myself am more comfortable with it, simply because that is how I first studied his work.

123

thing. The effect of an upward flowing consciousness may defy analysis; it may simply be experienced by the viewer, afterward, like the joy I experienced after meeting Ernest Wood.

An artist with an uplifted state of consciousness would manage somehow to lift our hearts along with his own, no matter what he painted. It is a question, ultimately, not of science—that is, of technique—but of art.

In everything he does, an artist will be better able to inspire others if he directs his energy and consciousness upward from its present center. This he will find easier to do, the more he diminishes his sense of personal importance.

It is interesting to note how many great artists have lost their sanity. The dividing line between genius and madness, it has been said, is paper thin. Yet as far as I know, insanity, prior to the Romantic Movement of the Nineteenth Century, was no more common among artists than among any other class of human beings. Why is genius nowadays so often equated with a loss of mental equilibrium? Consider the cases of van Gogh, Robert Schumann, Hugo Wolf, Friedrich Nietzsche: The list is dismayingly long.

Again, why? Certainly, an excess of energy to any part of the body can have a damaging effect on the nerves in that part. Too much energy to the brain, also, is capable of disturbing a person's equilibrium. Does this mean, then, that the solution is to direct *less* energy to the brain? Creative genius notably expresses high energy. Genius, moreover, operates principally through the brain. Shall we then offer as a solution for artists the suggestion that they devote

less energy to producing works of art, and more, perhaps, to gorging themselves at the table?

Fortunately, this is not the solution. For it is not energy to the brain that causes mental imbalance. It is blockage of the flow of energy *within* the brain.

This blockage occurs particularly when there is a strong emphasis on the ego: in the case of the artist, the thought, "I—I—I am the one creating this masterpiece!"

The energy flowing into the brain must be free to flow onward, beyond the ego. In a sense it is like tension in the body: If the tension can't be released, but is held there too long, physical damage will result.

Again, think of a freeway with only a few cars moving along it. At a certain point on the road, two cars are stopped because of an accident. The other drivers, observing them, slow down a little. Perhaps their reason for doing so is that they wonder if they can be of help. Or perhaps they slow down out of curiosity. In any case, since the traffic is light on the freeway, its overall flow will not be greatly affected.

Now, suppose it is rush hour and the freeway is heavily crowded. Drivers, on seeing those two cars stopped, slow down as they did before. But because now there are so many cars, the slowing-down process results in stop-and-go driving for as far back as a mile or two.

The brain, during any intense flow of creativity, is more likely to experience energy blockage like the blocked traffic during rush hour, than while a person is seated comfortably, reading a book. The cause of such an energy-block, usually, is the ego. Like those two cars stopped by the roadside, the

125

artist may find his attention attracted by such thoughts as, "Look what *I'm* doing!"

There can be ego-awareness without it necessarily posing an obstacle. Indeed, some ego-awareness is necessary, for the ego is an energy-motivator.

Ego is what gives human beings the incentive to seek solutions to their difficulties. It generates the desire for self-improvement, for creative activity, and, ultimately, for self-transcendence. If the energy remains focused in the ego, however, instead of being allowed to flow on toward a broadening awareness, then instead of helping us to grow toward further understanding it becomes mired in pride and pettiness. If, at the moment of inspiration, the ego intrudes itself with the cry, "Look at me!" it blocks the onward flow of energy.

The simple thought, "It is *I* who am painting this tree," as opposed to, "What I am painting is a *tree,*" is enough to hinder the clear flow of inspiration. In this case, the greater the creative flow, the greater the blockage of energy. Creative artists are more apt than many people to be egotistical, not because their egos are naturally stronger, but simply because during creativity there is an increased energy-flow to the brain. Temptation awaits them in the thought, "See what a good artist I am!" It is important for them— for artists more than for less creative people—to exclude the ego-principle as much as possible while at work.

Paramhansa Yogananda stated that the seat of ego in the body is the medulla oblongata at the base of the brain. It is interesting to note how emphasis on the thought, "I," produces a greater focus of energy at that point. Try it. See, for example, what happens

when you accept too personally another's flattery. And notice the tendency that proud people display to hold their heads "high" as if they were looking down their noses at the world. Tension at the back of the head makes them draw their heads backward. In Italy, the expression is similar: Instead of calling it "looking down the nose" they speak of seeing the world "beneath the nose."

The way to remove this energy blockage in the ego, Yogananda said, is to divert concentration forward in the brain from the medulla oblongata. Best of all, focus it in the seat of superconsciousness in the forehead, between the eyebrows. Next, try to penetrate that point mentally. Project your energy out to the inspiration you hope to manifest.

Even people who lack awareness of the energy-flow in the body should find it easy to understand how the ego becomes an obstruction to creative self-expression. For it is always more productive to think, "What is appropriate?" than, "What do *I* want done in this situation?"

The ego, then, plays a role in creativity, as its generator. It must, however, keep a firm rein on the flow of thought to make sure that the mind doesn't get sidetracked. For there arises constantly in the mind the temptation to turn creativity to prideful ends.

Among famous composers, indeed, the only one I know who doesn't seem to have succumbed to this temptation at least occasionally was Mozart. So true was he to his musical inspiration that, when his publisher wrote to him, "If you don't consent to write music in a more popular vein, you will starve," Mozart wrote back, "In that case, I have

127

no alternative but to starve. For I can only write what I have been given to compose."

The ego's role is, indeed, central to the creative act. The important thing only is that the ego join in the fun, so to speak, and not ruin everything by calling excessive attention to itself.

There is much more joy in offering ourselves up to a higher power, and asking that power to create through us, than in taking onto our own shoulders the burden of impressing the world with our "genius." As Ian Fleming once said, "Fame was fun for awhile, but now it's just ashes, old boy. Just ashes."

True creativity is ever new. It is ever fresh. When its flow is as clear as a crystal stream, the demands of every work we create become unique. Every moment is lived purely for itself. The more truly creative an artist is, the less he thinks of drawing on past associations of thought and experience. He lives *here* and *now,* and seeks ever to ride on those currents in the sea of thought which take one to new shores, and never twice to the same spot.

# Art and Meditation

Visualize two pyramids floating on the surface of the sea. One pyramid has its tip at the surface, like an iceberg. The other, being lighter, is inverted: Its base is at the surface, and its point underneath.

Many works of art are like that second pyramid: everything showing at the surface, but with less and less substance the deeper you probe them for meaning. Great works of art, on the other hand, usually show us only their tip: Their substance is well below the surface.

Understatement, as I have already said, is the essence of good taste. A person whose feelings run deep doesn't shout them like the barker at a circus sideshow. Braggarts hope by loud boasting to be heard by as many people as possible. They intrude themselves over the hubbub of a crowded room. Sincerity, however, speaks softly. It *offers* the truths it utters; it doesn't impose them on anyone. For it knows that the truth is arrived at sensitively, and only by the exercise of free will.

Without subtlety, there cannot be true art. What wells up from the depths of our being is an expression of the soul; it is very different from the noisy bursts of enthusiasm so common to television advertisements.

Works of art that have only entertainment value may shout, scream, and splash sound and color about with reckless abandon. I am not addressing that level of creativity. But works that express soul-consciousness are gifts from a higher world. To produce such works is impossible without inner stillness. You cannot merely *affirm* soul-consciousness: You must *experience* it.

Meditation is, therefore, an important part of the artistic experience. Not all good artists meditate, though I suspect more of them do so than are themselves aware of it, or than speak of it to others. Meditation is the breath of inner silence. Without silence, the wellsprings of inspiration are polluted; they become, at last, undrinkable.

The West knows little of meditative practices, though many thoughtful Westerners make it a practice to seek relaxation in daily periods of stillness within. The East has made meditation a specialty. The yoga teachings of India, especially, offer what has been justly called the *science* of inner unfoldment. Admittedly, it is not their explicit aim to promote artistic creativity. Rather, their goal is attunement with the higher Self. Even so, the outer effect of yoga practices is that they enhance our every undertaking by developing concentration, and by putting us in touch with the true source of all inspiration.

Meditation is especially important for artists that seek to express a more refined awareness than one can if he depends too much on the rational mind. Art ranks high, for this reason, as one of the natural, even though outward, fruits of meditation.

You will find it helpful, before seeking to create or express anything that requires sensitivity, to sit for at

least a few minutes in inner silence. The longer you sit, the more refined your awareness will become.

Concentrate your gaze and attention at the "spiritual eye," in the forehead between the eyebrows.

Begin with relaxation of the body. To do so, first inhale and tense the body all over. Then throw the breath out, simultaneously releasing tension throughout the body. Repeat this exercise one or two times. Then concentrate on the feeling of freedom from physical tension. Think of space in the body, and surrounding the body.

Relax mentally also. Think of space spreading out in all directions to infinity, releasing you from all worries, from any regret for the past, from all plans for the future. Tell yourself that the world will still be there, with its chaos and frustrations, when you leave your meditation. There is no need to bind all your responsibilities together with a rope of thought! Tell yourself instead, "When I go to sleep for the night, I let go of everything. More briefly now, I'll leave it while I meditate."

And then, concentrate with a completely relaxed mind, without any sense of strain, on the thought of offering every feeling, every thought onto the altar of silence within.

What is life, without art? And what is art, without love? Love takes us beyond emotion: In its purest essence it is a deep soul-intuition. When you offer up the feelings in your heart in joy to the Divine Presence within, you will know what soul-love is.

From that love is born the highest art. Meditation, as I've already said, is the breath of inner silence. To this thought let me add another: Love is the breath of all true art.

Each one of us has an eternal story to tell, his own unique life's pilgrimage, his own path to the discovery of truth and meaning and selfhood.

Sooner or later, art will become for you an expression of wordless yearning for the source of your own being. And then at last, leaving art itself behind, your soul will offer itself to the Divine Mother of all life. Love alone, then, will be your "art." And your heart will sing in resounding but soundless melody:

Love is all I know:
Sunrays on the snow
Of a winter long
in darkness, without song.
Oh, my heart's afire,
Burning all desire.
Only you remain,
and life again.

Too long I did stray,
Flung lifetimes away,
Imagined you did not care.
I know now your smile
Was mine all the while;
I listened, and love was there.

I can't breathe for love!
All the stars above
call to me, "Come home!
Life's waves all end in foam."
Only love can heal
All the pain I feel.
What a fool was I
to turn away!

The highest state, while still we possess our human faculties, is not to lose ourselves in infinity, but to offer ourselves as completely as possible as clear channels for the expression of infinite love and joy. Art, then, which at first is a means of helping us to reach that state, is also one of the means by which that state of consciousness can reach out to touch others.

Even in the sharing, you must be clear as to how you invite the Absolute to express itself through you. Inspiration won't come to you without invitation.

Superconsciousness will inspire you according to the questions you pose it. If you ask for musical inspiration, musical inspiration is what you'll receive. It is unlikely, in this case, that inspiration will come to you in the form of a mathematical formula. If you ask for guidance in writing, that, again, is what you'll get; it is improbable that you'll receive a recipe for food—unless indeed what you're putting together is a cookbook. All inspiration is available to you in the higher Self. It therefore follows, of course, that if you do deeply seek a mathematical formula, and if you prepare yourself to receive and understand it, there is no reason on earth why you shouldn't receive that, too.

Remember for now that even a little lack of clarity at the source of creativity may result in no clarity at all at the end.

To achieve inner clarity, certain attitudes are necessary. The most important of these are faith (as I've stated earlier), openness, and love. Patience too is needed, for the answers don't often come at the very moment that you ask for them.

And yet—they may also come at that moment, if you make your demand with intense love and expectation. Love is what generates the highest energy.

Before you ask inwardly for guidance, be clear in your mind as to the sort of ideas you hope to express. If you plan to write a piece of music, tell the higher consciousness the subjects you want to cover. Ask, then, for inspiration on specific aspects of that subject. Don't merely say, "Give me something peaceful," but visualize peace of a particular kind, or in a particular setting—perhaps peace in the evening with the moonrise on a lake, and the tranquil effect of that scene on a mind that is in need of respite after the day's turmoil.

Here, too, is an important adjunct: Let your mind flow forward, completely confident that the inspiration you want stands before you, its arms outstretched, waiting. This is faith, faith that requires an unhesitating commitment of energy.

Years ago I wanted to write a melody for St. Francis of Assisi's best-known song and poem, "Canticle of the Creatures." My problem was that the stanzas were so irregular that in one of them a line might have five syllables, and the same line in the next stanza, twenty-five. For years I was thwarted by this difficulty.

Then one day I *needed* a melody for that poem. I was writing music for a slideshow of the life of St. Francis, compiled from photographs I had taken in Assisi. How could I leave out his most famous poem—the first, it has been said, in the Italian language?

I strongly visualized him as he was described when he first sang it to Sister Clare and a brother

134

monk. Legend tells us that he had risen from his death bed, and was leaning, upright, against a tree, blind and very ill, but triumphant in the joy he felt in his love for God.

When the image came clearly to my mind, I offered it up in prayer and asked to hear St. Francis singing that song. To my great joy, the melody came to me instantly. It was one that could be expanded or contracted to fit every stanza. And it expressed, at least to my satisfaction, the power and beauty of the words.

It isn't enough to receive the initial inspiration for a creative work. One must continue to hold his mind up to that inspiration, in order that every note, every brush stroke, every word remain faithful to it. It is tempting sometimes to settle for an easier solution, a solution permitted by the rules of music, and to which no one would object. The temptation arises not only because traditional solutions are the easiest, but because it takes considerable mental energy to continue holding your consciousness up to the inspiration you felt at the outset as you carry a work to its completion. The mind wants to say, "So much for inspiration! Now let me concentrate on the work." But inspiration is not a motionless tableau: It is vibration; it is living. You must keep your heart dancing in it, if you would infuse into your entire work its creative influence.

Inspiration should be awaited in the heart, then held up to the "spiritual eye" in the forehead. A cycle of energy is formed thereby, uniting the two.

Inspiration of this kind is already, in itself, a form of meditation. For it deepens our attunement with the higher Self.

135

Of the heart, ask love. Of the "spiritual eye," ask wisdom. Ask that what you create be in tune with both love and truth. Never allow yourself to express anything that you don't really feel in your deepest self to be true. To do less is to prostitute your talent. More and more, if you compromise your deepest principles, you will find your talent diminishing, until you discover that you, yourself, left to your own devices, were never anything but a very mediocre artist.

I attended a violin concert years ago. The violinist, a young woman, was expert at playing fast and difficult passages flawlessly. Afterward, the organizer of the event exclaimed enthusiastically, with a strong eastern-European accent, while placing great emphasis on that first syllable, "She iss a *geeenius!*"

Yet all the violinist had done was show off her mechanical dexterity, which, admittedly, was considerable. Did that make her a genius? She had chosen pieces that would demonstrate this skill, rather than others that would reveal her sensitivity or lack of it, or that would inspire her audience. Did that prove her a genius?

Indeed no one, really, can *be* a genius. One may *express* genius: That is another matter. One may be an *instrument* of inspiration, granted. But one may never claim to be the *possessor* of that inspiration.

If we are sincere in our efforts to express inspiration, and if we never falter in our faithfulness to what is given to us, our ability to express it will increase. No artist should expect more. *The artist is influenced by whatever state of consciousness he invites into himself.* He *becomes* that which he expresses. It

affects him, personally, far more than it ever can his public.

If a person decides to write, or paint, or express himself artistically in any way, he should know that negative self-expression will not bring relief to his negative feelings; it will only reinforce them. The expression of darkness only generates more darkness in the person who expresses it. The expression of light, on the other hand, brings light into the life of him above all who offers himself as a channel for the light. Darkness begets sorrow, suffering, and despair. Light inspires understanding, acceptance, and joy. Is the choice between these two really so difficult to make?

If you want to know joy, seek to express joy. If you want to know beauty, seek to express beauty. If you want to know wisdom, seek to express truth in everything you do.

Wise people claim that if a person will always adhere to the truth, his simple word will become binding on the universe.

The story is told of a great musician, Tan Sen, in the court of the emperor Akbar, in India. One day Tan Sen was asked to play an evening melody at high noon. Shortly after he began, the palace and the surrounding precincts were plunged in darkness.

Such, indeed, is the power of art, when, attunement is sought through it with the Power that brought the very stars into existence.

CHAPTER THIRTEEN

# Art as Language

Everything we do is an expression of our consciousness. Our thoughts are like ice fragments on a river in spring. Just as the ice is formed out of the same element as the water on which it floats, so our thoughts consist of the element—consciousness—out of which they appear. Thoughts are produced by consciousness. They are not, as Descartes claimed, the producers of consciousness. Like an ice floe breaking up into smaller and smaller fragments with the season's thaw, consciousness becomes increasingly defined as specific thoughts in consequence of the "thaw" of *chitta** and the slow arrival of summer, in the long evolutionary process, of self-awareness.

The quality of our consciousness reveals itself in the specific expressions it takes. And here the metaphor no longer serves our needs. For consciousness reveals itself in terms much more varied than mere form.

Human speech is only the most obvious of its manifestations. Speech is communication, and communication is not limited to words. There is also what is known as body language. There are the feelings we convey through our tone of voice, through

---

*A Sanskrit word that means the feeling aspect of consciousness.

the pauses between our words, through the rhythms of speech. Most human communication, in fact, is non-verbal.

The appearance of thoughts in the river of consciousness begins, not with the dawn of intellect, but with the appearance of feeling. On the refinement of feeling, far more than of the intellect, depends the evolution of human understanding.

Hence the vital need for art, and for its wise development. Far more than philosophy, art can lift our minds toward higher understanding.

Art, when perceived as a means of communication, is one of the most important languages the human race has produced. Unlike spoken language, moreover, the language of art is universal.

To a literal mind, art seems to have nothing particular to say. The literal-minded person may enjoy seeing a pretty painting of trees, fields, and flowers, but if you asked him what it all meant he'd look at you in bewilderment, then perhaps answer, "Why, it means trees, fields, and flowers—I guess. What else *could* it mean?" Ask him to write a poem describing the scene, and he'd come up with something like:

> I saw a few trees on a hill.
> They were green and tall. Their trunks were
>     brown.
> The grass underneath was green, too, but not so
>     tall.
> And there were flowers, here and there.
> They were real pretty.

His mind is as yet like the vernal ice floe, of which the fragments have still to gain clearer definition. Everything people do, however, says *something*. The

purpose of art is simply to help them become more articulate.

Consider art, then, as language. The more conscious we become of it *as* language, the better we'll attune ourselves to what it is saying. Let us first consider the "music" with which we are most familiar: human speech.

Rising notes in the voice suggest a sense of inquiry, of expectation, or of hope. Descending notes may indicate disappointment, sorrow, or—if they are expressed forcefully—determination.

Emphasis on consonants indicates will power. Emphasis on vowels indicates emotion, or feeling. Nasal speech may indicate pride, or a desire on the part of the speaker to remove himself mentally (perhaps not in pride, but only in shyness, or from a wish to be polite) from his environment. The softness or harshness of a person's voice can indicate kindness, love, irritation, anger, or enthusiasm. All of these feelings are conveyed to the listener instantly, though often subliminally.

Most people are only minimally aware of nonverbal communication as a language in its own right. I myself have been made aware of this phenomenon during a lifetime of traveling around the world. And I am convinced that in this general direction lies our civilization's next step in its artistic development.

For the problem presently before us is how to lift the arts out of their mire of meaninglessness. Yet we don't want, in the process, to revert to the rather literal conventions of a by-gone era, when every effort was made to show things just as the human eye beheld them.

Michelangelo himself, who took the human form as far toward perfect realism as it would be possible to go without becoming grotesque, began exploring in his later years the possibilities offered by more impressionistic work. The opportunities, however, for such subtlety of insight as man now possesses did not yet exist in those days.

I said in an earlier chapter that no mere technique of artistry could ever convey feeling. A certain curve of line in a painting, for example, might succeed in conveying a sense of joy, but no automatic repetition of that curve could ever duplicate the joy. Words alone, without feeling, could never convey the feelings they communicate when uttered sincerely.

Yet there are rules to the game, and if we apply them with insight they can facilitate clarity in the expression of our feelings.

Consider color. Do not bright, clear hues suggest more spiritual states of awareness than those which are muddy? Can you imagine Leonardo's *Last Supper* done in dark, heavy tones? He could have done so only if he'd wanted to convey a deep sense of suffering, and not the divine inspiration of the Eucharist.

Dark colors in Leonardo's paintings, all of which convey a subtle spiritual message, serve only to emphasize the lighter central figures. In a sensual or violent painting, however, muddiness is predominant.

Different colors suggest also different states of consciousness. Blue, for instance, is more soothing than red. Orange is more energetic than green.

Consider lines: Short, straight lines and sharp angles, if used sparingly, suggest will power; if used indiscriminately, tension. A multiplicity of sharp

141

angles suggests a tension bordering on nervousness. Curves imply harmony, adaptability, and rest. Curves that are softened in their outlines may connote a meditative peace. But a painting that contains too many curves and no straight lines gives a sense of vagueness and of lack of discrimination.

Putting it another way, we may say that straight lines represent *doing,* and that curved lines and circles represent *being.* Again, straight lines and sharp corners represent masculine energy; curved lines, feminine energy. Straight lines also express Western culture; curved lines, the culture of the East. In art, these two energies should be brought into harmonious balance.

Years ago, I visited Chandigarh, India, the architecture of which was designed by the French architect Le Corbusier. I was interested to note how out of place those straight, Western-inspired lines seemed, rising as they do out of timeless plains.

Curves are a more natural architectural expression of India's ancient civilization. They suggest a national consciousness that, over millennia, has become smoothed and rounded like pebbles in a riverbed, adapting instinctively to the universe and to life's vicissitudes. Straight lines and sharp angles, more natural to Western culture, suggest Western man's determination to conquer Nature—to bend her to his will. Chandigarh seems to me an insensitive intrusion into another state of reality.

Consider tempo in music. Who has not felt the exciting influence of fast music, or been soothed by a slow, measured beat? Musical tempo is related in our subconscious to the heartbeat, which speeds up under the stress of emotional excitement, and slows

down when we are feeling relaxed and peaceful. Both tempo and heartbeat are as capable of affecting the emotions as of being affected by them.

Consider rhythm. The first beat of a musical measure represents the "I." If heavily affirmed, this beat implies a forceful ego. But if lightly affirmed, our spirits receive the message to rise and fly.

If the first beat is affirmed slowly and repeatedly, without deviation, we begin to feel as though we were treading sedately through life, impervious to the feelings and opinions of others. Haydn's music is an example of this sort of attitude. Despite his genius, many people consider him a bit of a stuffed shirt.

The first beat of a measure, when affirmed slowly, repeatedly, and *heavily,* suggests an ego so firm in its own convictions that it is willing to march roughshod over everyone who opposes it. Hence military bands, John Philip Sousa, and the whole gamut of martial music. Hence also the kind of hypnosis that affects soldiers as they march. The drumbeat motivates them to advance fearlessly into withering enemy fire.

When the first beat is affirmed repeatedly and rapidly, a highly suggestible ego may be lifted into a hysterical rhythm that is foreign to its nature, and induced to behave in ways contrary to human norms.

If the first beat is virtually suspended for whole measures at a time, as often is the case in the Indian classical *raga,* when melody and accompanying rhythm temporarily go their separate ways, the resultant diversion from self-consciousness can have the

effect of reemphasizing it again on a higher, soul-level, once the original beat is at last resumed.

The other beats in a measure, being subordinate to the first, take their basic direction from it. They reveal the *quality* of the ego's drive, enthusiasm, or initiative. Six-eight time, for example, is more graceful; four-four time, more determined.

Rhythmic deviations, if held in control by the first beat, may suggest a "cool," uncommitted ego. Such a person is always surprising others, generally not from a wish to entertain them, but rather because he doesn't want to feel bound by their expectations of him. If the syncopation is kept light, it can suggest a joyous sense of inner freedom. But if heavy, and particularly if coupled with a heavy downbeat, the implied lack of commitment may also connote contempt for, or indifference to, the needs of others.

What one gives out to the world, however, will be given back to him in return. If one is too much interested in dishing out surprises, for example, he may end up being surprised himself. Syncopation can be increased to the point where it suggests unexpected events being inflicted *upon* the ego, rather than *by* it. "Jagged" rhythms in which the first beat—that is to say, the ego—no longer seems in control betray nervousness and insecurity: an ego threatened by an unpredictable and hostile universe. This influence we find in a great deal of modern music, symptomatic as it is of a restless and disoriented age.

Consider harmony. Chords generally imply human relationships. Loud, full chords give the impression of a crowd of people. Soft chords suggest more a subjective relationship with others. And in

small orchestras of four or five instruments the effect may be wholly subjective, implying a relationship rather of different aspects of one personality.

Undeviating harmony suggests relationships that are bland to the point of being boring. Occasional discords, crying out for resolution in harmony, suggest those challenges and superficial differences which add delight to any human relationship. A continuous succession of discords, however, suggests friction and disharmony.

Modern music lays considerable emphasis on dissonance, just as it does on syncopation. In this fact, too, is revealed an age out of harmony with itself.

Consider melody. The melodic line in a piece of music represents our inner aspirations. In addition, it represents our subjective reactions to the objective world. A rising sequence of notes tends to lift our consciousness; a sinking sequence, to lower it—though perhaps only in firmness of affirmation, not necessarily in sorrow.

Sub-melodies represent secondary, and often hidden, yearnings and desires in the personality.

High notes in the melody, coupled with a heavy downbeat, suggest an idealistic ego. (Note this effect in Beethoven's famous "Ode to Joy," in the last movement of his Ninth Symphony.) Even in a high or rising melodic sequence, however, if it is dominated in the accompaniment by low notes, and particularly if the downbeat is heavy (here, rock music springs to mind), the impression conveyed is sensual or otherwise heavily physical.

Again, the complete lack of a melodic line—another feature of much modern "classical"

music—suggests want of aspiration or ideals: an inner self adrift on an uncharted sea.

It is interesting that Indian devotional music, though highly melodic, is devoid of both harmony and sub-melodies. Western religious music, with its intricate counter-melodies and harmonic patterns, is considerably richer. Which is better? The two statements are simply different.

Richness is something the Indian tradition seeks to avoid, owing no doubt to its stress on personal, *inner* communion with God. Western religious music is usually associated with communal worship. The Western form may also suggest the crosscurrents of yearning that make up the complexities of the human personality. Indian religious tradition, by contrast, ignores the human personality more or less altogether, and concentrates on the soul's eternal longing for its divine Source in God. Through music, the Indian worshiper is taught to seek attunement, ultimately, with *Aum,* the Sound-current of the Infinite.

The two traditions are simply different. Inevitably, therefore, the music that sprang out of them is different also. Each reflects the basic attitudes of its own culture.

The important thing at all times, when expressing oneself artistically, is to hold before the mind the thought, and especially the feeling, that one is trying to express. One should refer back to this concept again and again as he progresses.

# Art Is an Expression of Energy

The *sine qua non* of greatness in every form, whether artistic or human, is *energy*.

Thomas Edison claimed that genius is "one percent inspiration and ninety-nine percent perspiration." Another famous definition of genius was stated by Jane Ellice Hopkins: "Genius is an infinite capacity for taking pains."

With due deference to both those famous persons, however, it seems to me they fail to convey the truth they intend. Many great works have been born not laboriously or with pain and perspiration, but quickly and easily. It was almost as if they created themselves.

Franz Schubert wrote eight of his best songs, from the *Winterreise* sequence, in a single afternoon. Shakespeare is said to have tossed off his comedies almost carelessly.*

---

*Careless sometimes he most certainly was. Consider the shockingly casual way, in the final scene of *As You Like It*, that he fairly washes his hands of the story. Realizing that he must somehow dispose of the villain, Duke Frederick, who was last reported advancing with an army, he offers us the totally unexpected, in fact incredible, report of the duke's sudden conversion and withdrawal into a monastery. This is, I think, the most improbable religious conversion in all of literature.

On the other hand, I remember reading in the newspaper about an immigrant to America who had wanted to express his gratitude to this country for allowing him to come here. For twenty-five years he labored zealously to create, out of matchsticks, a towering replica of the Statue of Liberty. I felt a deep pang of pity when I saw a photograph of this monstrosity in a newspaper. For the man's motives were noble. Yet his work was proof as pathetic, surely, as anyone ever gave of the relative unimportance of perspiration in the formula for genius.

*Energy,* not drudgery, is the true key to greatness. Edison might justifiably have given energy 100% of the credit. For a strong flow of energy, like the flow of electricity in a copper wire, creates a magnetic field that actually attracts inspiration to itself. A great amount of energy applied to problems may bring speedy solutions, where low-keyed deliberations will always, even after laborious months or years, end in bathos or in half-hearted compromise.

Great works invariably proceed from great resources of energy. Sometimes it is necessary to apply this energy painstakingly. One's co-workers, if any, may abandon the job in exhaustion or despair, as Edison's pleaded with him to do after 20,000 failed attempts to find the right filament for an electric light. Edison persisted, however, completing 43,000 experiments before he succeeded. Genius may indeed involve "perspiration." But the same energy may also achieve results with such lightning speed that everyone is left gasping for breath. In any case, the strength of the energy-flow, not the doggedness of one's perseverance, is what determines the quality of the results.

A strong flow of energy can be vividly sensed in all great works of art. They carry an almost tangible aura of vitality. On the other hand, vitality is the one thing most conspicuously lacking in minor works.

In a minor novel, the villain seems merely unattractive; the hero, only less so than the villain. The professor, if there is one, impresses the reader as a tiresome pedant. If a rustic adorns the tale, he is so convincingly dull as to be simply uninteresting. Ennui wafts though the pages of such books like marsh gasses on a tired breeze. And facts—a plenitude of them—are frequently offered in desperate compensation for an utter dearth of insights, of vital reactions and observations.

In a work of true clarity, however, even far-from-edifying characters somehow charm us, or thrill us with their mysterious power. The villainy of Shakespeare's Iago suggests almost a primal force. The pedantry of Polonius is a sheer delight; at the same time, it is unexpectedly wise. Caliban's loutishness, in *The Tempest,* qualifies him as a veritable king of louts. And the ineptitude of Bottom, the weaver, in *A Midsummer Night's Dream,* is, from start to finish, inspired.

Energy is the redeeming quality in the works of many lesser artists, too. François Villon, thief and notorious troublemaker though he was, wrote poetry of such intensity that it is still counted among the best literary products of his age.

In every case, it is *energy* that makes possible vital expression in the arts. Energy is the starting point of greatness, and the ladder by which every successive stage to greatness is achieved.

# Seeing Underlying Relationships

At the surface, how different we all seem from one another! Fishermen, shopkeepers, doctors, lawyers, factory workers, housewives; Americans, Chinese, Frenchmen; rich, poor, energetic, lazy: The variety is endless. No two thumbprints are exactly alike. It is man's most primal instinct, bound as he is by ego-consciousness, to distinguish himself from others, and then to emphasize the distinction.

The sense of kinship with our fellow creatures usually evolves out of much suffering. For suffering helps to erode the thick walls of egotism.

The vision of unity in apparent diversity is common to people of clear insight. It is a vision, however, toward which one can grow only by gradual refinement. It cannot proceed from any mere shift in opinion or philosophy.

And that unitive vision is valid. For such is the nature of things that, behind their mask of individuality, differences disappear. All living beings, all things, all thoughts, all emotions and inspirations are like waves on an ocean, endlessly varied, yet forever manifesting a single reality.

This is the vision that science has shown us of matter. It is the vision that the Scriptures have given us of life. And it is the vision artists achieve, once they truly understand their fellowman.

For understanding comes more by empathy than by cold analysis. Only by genuine kindness can we really get to know one another. Thus, in the hands of such a true friend of humanity as Shakespeare was, even a villainous Shylock seems, at last, pathetic as well—as though, given just the right circumstances, any one of us might have fallen into his delusions.

Indeed, a dramatist of Shakespeare's stature makes the more sensitive members of his audiences feel that in Shylock's fall lies the potential for their own fall. For the life in them is also that which gives birth to people like Shylock. In our deepest reality, we *are* Shylock, and Shylock is each one of us.

The man does not exist who doesn't contain within himself the seed reality of all other men.

The attainment of clarity in the arts, then, as also in human awareness, involves an ever-clearer perception of underlying relationships between dissimilar-seeming people, places, and circumstances. Its vision is unitive.

CHAPTER SIXTEEN

# "Facing the Darkness"

Some years ago I was invited to lecture before a community in Germany that was dedicated to practicing the principles of Carl Jung. The members believed in "facing the darkness" in themselves by practicing total self-honesty. Determined to conquer their human tendency to rationalize their faults and weaknesses, they not only did their best to face these inner demons: They brooded on them.

Every morning they would sift through their dreams of the night before in hope of deepening their insight into those subconscious desires and frustrations which, as we all know, keep people from becoming the free spirits they'd like to be.

In principle, what they strove for was admirable. Freedom from our mental demons requires, first, that their existence be at least recognized. Second, it requires that we face them courageously. By fear, we only give them power.

I've listened to this approach to self-betterment with misgiving, however, sound though it appears in its rationale. My main problem with it is the grim earnestness I've observed in people who endeavor to probe into their inner "darknesses."

The members of that German community didn't seem at all free, inwardly. Indeed, they seemed overwhelmed by their "darknesses." During the two days

I spent there I saw no one smile. Tight-lipped, grim-faced, and staring at the ground about sums it all up. Later, I learned that there had been several suicides in the community—hushed up, but a burden on the group conscience all the same.

The members challenged my definitely lighter outlook on life. Finally their leader, after failing to break down my reasonable defenses, exclaimed in exasperation, "My dear sir, you are *too* reasonable!" If by "reasonable" he meant that I choose to accept the guidance of common sense, I must plead guilty.

Merely to recognize a problem intellectually, and even to face it bravely on that level, isn't the same thing as overcoming it. The more intelligent a person, often, the greater the pleasure he finds in exposing to himself and others the intricacy of his mental rationalizations. He falls anew into the trap of egoism.

Real understanding of our inner darknesses must penetrate to those levels of awareness where they have their existence. We cannot approach them only on an intellectual level, for they don't reside there in the conscious mind, but muster their forces in deep caverns of the subconscious, hatching dark plots for the invasion of our peace of mind.

A better way of winning against these forces of inner darkness is on a level of feeling. "Perfect love casts out fear," the Bible says. Positive feelings alone are capable of directing enough energy to dissolve the vortices of negative traits, and to draw them upward in a positive flow. Negative traits are the consequence of negative currents of energy. Once those currents become positive, they are transformed. Vice becomes virtue. Hatred becomes love.

All our darknesses, of which fear is only a sample, can be transformed into shafts of light by the magic of upward-aspiring love.

The best way to generate positive energy is by positive action. Intellection alone cannot do it. Positive action combined with positive feelings is the best way of converting our inner foes into loyal friends.

Art, because it combines feeling with action, is an excellent means of effecting our self-transformation.

I don't mean that we should neglect the intellect. If we ignore it, it may undermine with sly casuistry our best-intentioned efforts. Few people, however, can afford to begin their journey toward enlightenment from this end of the course. Self-analysis may become then, instead, the first stage on a journey to self-paralysis.

By concentrating too much on our "darknesses," we sink into a chasm of despair. Concentration on darkness only affirms it. By gazing at it too closely, we magnify its size even as a microscope makes microbes loom monstrous before our gaze.

The best way to rid ourselves of darkness is to concentrate on that reality which alone can banish it: light. Armed with the sword of inner light, we can slay our enemies of darkness one by one, or all of them at once in a mighty sweep of ecstatic love. We can also, in the process, come to understand them with perfect clarity—far more so than we ever could as long as we viewed them in their shadow state. Darkness can be rightly understood only in its relationship to light.

The artist serves the cause of truth best if his view is from a mountaintop, and not from the bottom of a well.

A college classmate of mine years ago informed me that his mission in life was to write the Great American Novel.

"In what way do you want your novel to be great?" I inquired, intrigued that anyone would simply sit down to write a great novel.

"Well, just great. I mean, you can't go beyond that in defining a thing, can you?"

"Well, for example: Do you want to feel the psychic pulse of America? Do you want to inspire people with a vision of America's greatness?"

"Inspire?" he inquired, frowning suspiciously. "What do you mean by that?"

"Well, for heaven's sake," I replied, "inspiration can mean many things. For instance, it may mean helping people to become more sensitive to beauty."

"Beauty!" cried the great novelist, horror-stricken at my sentimentalism. "To the realist there is no such thing as beauty!"

Realism to him, then, if it didn't mean merely a dry catalogue of facts, could only have meant an exposé of the seamier side of life. To him it probably meant the latter, I thought, since exposing life's seamy side was already, even in those days, the vogue. People who set out deliberately to write "great" novels, after all, are nothing if not voguish.

I wondered whether his view of life had not been acquired by lying in gutters on Saturday nights, taking notes. He didn't look as though fate had dragged him into any such abyss. It seemed to me obvious, instead, that in the name of stark realism he had merely embraced a fad.

It is a common practice nowadays to dip pen, or brush, into a mudpot of squalor. The justification

for sordid revelations is, supposedly, that honesty demands an unflinching gaze at the worst side of life. And so it may, as I said. Between gazing unflinchingly, however, and fairly feasting the eyes one detects a subtle—indeed, a substantial—difference.

There does seem in fact to be a marked tendency for people who deny beauty to seek it again, perversely, in ugliness. One hears esthetes praise paintings and poems as "beautiful" that anyone of unschooled taste must surely view with repugnance.

Darwin may have been right when he traced human ancestry back to the apes, but acceptance of this family tree has led to a great deal of moralistic double talk. People since that time have spoken as though human beings were merely monkeys in disguise. Not only is it considered priggish to ignore the beast in us; we are encouraged to denounce the angel as a hypocrite.

And yet, our aspirations represent us at least as truly as do our defects. A musician, struggling to master a difficult series of notes, hasn't expressed himself fully until the outward act finally matches his inward ideal. What, then, of the angel in us? Is it realistic to dismiss him as a dream, when no work of art was ever less so until it became a reality?

Novelists have tried to depict as "basic" human beings the very dregs of society, as though the remorseless honesty of such people had stripped them of the frills with which an insincere and artificial age suffocates the rest of us. Such people are supposedly endowed with the wisdom to see things *as they are*.

If, however, we study these "heroes and heroines" in real life—people who drink themselves into a

stupor, or who give constant and free rein to violent temper, or who lead profligate lives, or who indulge in other similar examples of "basic honesty"—we find weaklings, not realists: emotional adolescents whose lives are founded on lies and delusions.

To *ignore* the existence of the darker side of life would be unrealistic, obviously. But to *embrace* this darker side, and to accept that it defines us as we really are, can only blind us to those realities which alone can take us out of darkness into light. Art that not only acknowledges, but that fairly revels in, the sordid aspects of life represents a step away from, not toward, whatever ultimate verities there be.

A work of art, as I mentioned earlier in this book, ought to be something we can cherish, and not be forced merely to endure.

It is natural to seek the company of people who inspire us. It is natural also to shun people whose company we find tiresome or depressing. It is easier to cherish a work of art when we feel that the artist has something to say that can guide and inspire us, and that doesn't reveal him to be merely lost, bewildered, and unhappy.

If after reading a book we conclude, "Well, this author certainly has his problems," we are unlikely to turn to him again except for that kind of company which misery seeks. Normally, what we want are solutions to our difficulties, not an increase of them. If the overall effect of a painting, a novel, or a work of music is depressing, we may safely say that its author has not yet achieved a clear vision of things.

For invariably accompanying a broad vision of life is a disinclination for all that is petty or mean.

Great art, inevitably, presents an exalted, not a debased, view of reality.

# A Generous Spirit

What makes Shakespeare so much greater than those two contemporaries of his, Beaumont and Fletcher? Is it not partly, at least, his generosity of spirit?

A study of the clearest and greatest minds of the ages reveals a generous spirit in all of them, to varying degrees. A more expansive outlook on life always inspires tolerance. Small-minded intolerance, on the other hand, is the salient feature of a nature mean and petty.

A great human being—one, in other words, of clear and honest vision—sees everything, including evil, from a standpoint of essential goodness. By this I don't mean that such a person is naive. For there are two kinds of innocence: that which is due merely to lack of experience, and that which comes from hard-earned wisdom. That side of human nature which reaches out to embrace universal truths achieves a vision much broader than any that comes from the narrow, "gut-level" preoccupations of so many slum "realists."

An artist of real insight can take us through suffering and despair to an *expansion,* not a destruction, of inner peace. Through pain he awakens in us a broader sense of the mystery and beauty of life. This effect was defined by Aristotle as a *catharsis.* The

starkest tragedy, if penned with wisdom, leaves us feeling cleansed, not despairing.

Despair is, in fact, incompatible with true clarity. For clarity implies understanding. And understanding comes with taking the world as it is, and ourselves as we are, accommodating ourselves to both, not in a spirit of complacency, but yet with a certain grace.

The broader the vision, the more positive it will be—not because it ignores human limitations, but because it sees them in the context of a greater whole.

A generous outlook unfolds automatically as our vision expands beyond its former, immature preoccupation with the strutting and self-proclaiming ego. The wise person's understanding of others derives not from callous judgment of them, but from a sense of his shared humanity with theirs. His insight is born of deep kindness, compassion, and good humor. His wisdom arises naturally from calm acceptance of life's vicissitudes.

# A High Purpose

Modern science may, as some people claim, have weakened what once were taken to be the logical foundations for a purposive view of life, but this view remains nonetheless instinctive in all human greatness. Even the great men and women of science cannot avoid it; they betray their loyalty to it by their constant search for reasons and explanations, where lesser scientists are contented with the bare facts.

So it is that the greatest works of art always suggest a kind of spirituality. I don't mean they are necessarily religious. Spirituality is not a banner that people wave to proclaim which side they are on in the game of life. Nor is it an exclusive feature of the cloister. Rather, it is an all-pervasive ingredient of life itself—broader than any creed, too universal for monopoly by any church: an elusive something that may light for a time on the heart of an agnostic, or shun for a lifetime the prayers of a believer with no love in his heart.

In certain works of true art this spiritual outlook is professed openly. In others it is conveyed indirectly, as a subtle effect. In either case, however, from the pure, childlike music of Mozart, through the hidden power in the sculptures of Michelangelo, to the sublime mystical poems, in our age, of Paramhansa Yogananda, the strain is unfailingly

present. It is the subtle breath of life, bestowing a magic charm on art forms that, in the hands of lesser artists, remain forever vague and lifeless.

This is the last, the highest secret of art. It is the ultimate secret of true genius.

# Where Is Art Headed?

There is no shock value in saying that we live in a time of moral and spiritual confusion; it is common knowledge. For most of the Twentieth Century, art has been wandering about in a state of bewilderment. Nowhere in the field is the problem more pronounced than in music.

Classical music, which ought to be in the vanguard of meaningful expression, has lost touch with melody. How? The explanation is best stated poetically: The fountain of melody is situated in the valley of the heart. It is fed by streams of inspiration, but vulnerable to the desiccating winds of intellectuality. When these blow unremittingly, the valley becomes an arid desert: Faith is then lost; hope is lost; love is lost. And the fountain of melody ceases to flow.

The chords also in classical music have tended toward dissonance, signaling inner tension and nervousness. The rhythms are jagged, as a person's speech is when he is mentally confused. And the supportive instrumentation is heavy with self-importance, pride, and callousness to the suffering of others.

In the visual arts, the impact of moral and spiritual confusion is softened only by the fact that color and design affect our feelings less directly than

music. Some day, perhaps, the visual arts will be refined to the point where light itself is used, rather than reflected light on a canvas.

In literature, finally, the moral predicament is not only implied, but stated explicitly. All too much so!

Popular music at least has retained some of its melody. For even when people are confused, they are clear about their basic emotions: anger, self-pity, romantic love. Popular music, in expressing them, is still capable of doing so melodically. The melody here is fading too, however—not because it is desiccated by intellectuality, but because it is dying for want of nourishment. The streams of inspiration have been dammed up by logs of egotism and self-absorption. In this sense, popular taste today is most worrying of all, for what it reveals is not confusion, but moral and spiritual paralysis.

The folk music of the past was exuberant, earthy, cheerful—or, when its mood darkened, heavy with sentiment and tragedy. Had it been expressed on a canvas, the artist would have laid the paint on with a trowel. Part of the charm of that music was its lack of self-consciousness. It accepted unquestioningly the customs and mores of the day. That recognition of an established order in life began to evaporate with the frayed nervousness of ragtime music. It was reaffirmed, but with bombast and unconvincingly, by the music of the big bands with their heavy emphasis on "I, my, me, mine." Since then, popular music has virtually surrendered its innocence to the pounding beat, the monotonous melodic line, and the absence of subtlety in chord progressions that are the rallying cry of rock music and its offshoots.

There is a kind of desperate howl in this music, suggestive of a pack of animals on a rampage.

What does this trend connote, if not a collective mind bent on self-destruction?

Wherever one travels in the world nowadays, the same maniacal beat assaults the ears. Cars pulsating with "heavy metal" or "rap" music make their presence felt long before they are even seen. What this "music" does to the minds of the occupants—to say nothing of their hearing—is serious cause for concern.

One wonders if our planet is not gathering force to purge itself of this epidemic of human confusion by some global cataclysm. Mankind seems to be actively courting disaster. The bullying beat of rock music and its increasingly rowdy descendants is inviting a grand finale of devastation: a massive explosion of some kind, whether by world war, or worldwide depression, or natural cataclysm—or a terrible combination of all three.

After every storm, fortunately, there ensues a time of calmness. Whatever disaster we attract, I believe it will, in the end, prove a blessing. Nor will it necessarily be an unmitigated evil even during its occurrence. For too much ease is always an impediment to progress. Hardship, like the grain of sand in an oyster around which a pearl is formed, affords us wonderful opportunities for inner growth.

And the first sign of this inner growth will appear, I believe, in the arts—especially in music.

If I am right so far about the future—if, in other words, we really are dancing on the brink of an abyss—then may this book play an important role in persuading people to pull back and take stock of

their position. I earnestly hope that what I have written will inspire a few artists, at least, with the faith too many of them have lost. If so, perhaps, gradually, art will be restored to its true role, which is to provide guidance, inspiration, and deeper understanding of life and of the universe around us.

When did people's sensitivity to beauty begin to diminish? It began after the dawn of the Industrial Revolution—in itself, in many ways, a benign phenomenon, but esthetically and in other ways a disaster. Profit and similar "practical" considerations began to take precedence over moral and spiritual values. Chimneys belched smoke up to the sky, covering cities with soot. Since that time the smoke has diminished, but toxicity has grown to the point that I can't imagine any self-respecting planet putting up with it for much longer. In some of the largest cities, the air is so polluted that it is difficult even to breathe.

Earlier, I mentioned John Keats's lament for the rainbow. He wrote, "There was a rainbow once in heaven. It is listed in the catalogue of common things." Keats's lament would be even more heartfelt today, when the rainbows over smog-blanketed cities have all but disappeared, and might well be listed along with condors and other fauna as an "endangered species."

From the home I built recently in Italy, the view is beautiful. From a height of 800 meters (about 2,400 feet), the plains of Trasimeno stretch away in the distance to my left. The city of Perugia, concealed by intervening hills, casts a warm glow into the sky at night. Alas, on some days the view can be

enjoyed only in memory. The valleys a short distance below me are barely visible, due to pollution.

The Industrial Revolution brought many advantages, including products, previously available to only a few, that now were accessible to many. The dark side of the story, however, was that people's refinement was somehow blunted, and their enjoyment of beauty, vitiated.

A creeping paralysis occurred in people's capacity for feeling. They no longer asked of anything, "Is it beautiful?" Instead what they asked was, "Does it work?" and, "How much is it worth?" Nowhere is this shift of emphasis more poignantly evident than on the island of Bali.

When I first visited Bali in 1958, it was a place of pristine charm. Terraced rice fields stepped down gracefully to little streams that flowed through verdant valleys. There were few cars. Electricity was almost non-existent. Few roads were paved. People traveled about on bicycles.

People's greatest delight lay in the dances, organized for their own enjoyment and not as tourist attractions. Hardly a thousand tourists visited there annually in those days. Those who came had to accept conditions that, by modern standards, were far from luxurious. (I remember one tourist complaining that his bed in the best—and perhaps the only—hotel in Den Pasar, the capital, was "so hard, I had to sit up halfway through the night just to rest my weary bones.") Bali in 1958 seemed to me a land where artists reincarnated. The beauty of the land and the tranquillity of the villages encouraged every artistic activity: music, sculpture, painting, dancing. All were in full flower.

I've visited there in more recent years. Bali, I regret to say, has been "discovered." Hundreds of thousands of tourists stream there every year; everything is changing for the worse. The landscape, the people, the atmosphere—all have been affected. Cars dodge determinedly about on paved, though still narrow, roads. Electricity has modernized even the small villages. High-rise hotels jostle one another for elbow room. And wherever one goes, one finds the hustling spirit in full swing.

One can still see Balinese dancing and listen to the xylophone-like music of the gamelan, but these performances are put on in tourist compounds. The visitor no longer treads uncertainly down back lanes to lantern-lit places of native entertainment. Everything is organized to maximize profit. In the process, unfortunately, something precious has been lost.

Bali was the most beautiful land I have ever visited. Its beauty, though still evident, is contained now, as if protected under glass. Bali, today, is an open-air museum.

Such, wherever one goes, is the world today.

I am not really worried about the future of mankind. It is the present that concerns me, rather. Humanity, and our beleaguered planet, will recover in time even if it takes some dramatic event to reawaken people to life's basic values.

Meanwhile, however, there is more from which humanity needs to recover than the shock waves of the Industrial Revolution. That sociological upheaval amounted to only the first knell in the clock tower of human faith. Midnight had come, and the end of a day. More knells remained to be struck.

Darwin's publication, in 1859, of his book, *The Origin of Species*, shattered many people's faith in the divine purpose of life. Thus sounded the second knell.

The third knell sounded near the end of the Nineteenth Century, with Sigmund Freud's publications regarding abnormal psychology.

Charles Darwin persuaded people to define themselves in terms of the subnormal. Sigmund Freud persuaded them to define themselves in terms of the abnormal.

Ideas have consequences. If we really are only primates "putting on dog," so to speak—monkeys dressed up in fancy clothes so as not to look like animals—then of course it is a mere affectation to try to refine our animal nature. A clown might just as well pretend to be a king as a human being pretend to be a saint, or to be possessed of noble qualities. If our animal nature defines us as we really are, then aberrations in human behavior may simply be, as Freud said, an attempt to suppress that reality. In this case, kindness is simply a disguise for avarice, generosity a disguise for personal ambition, and altruistic love a disguise for the more basic reality of lust.

Where the arts are concerned, exaggerated emphasis on the subconscious has produced more confusion than enlightenment. The best symbol for this trend was, perhaps, that "painting" by Picasso's monkey to which I alluded earlier.

The Twentieth Century has been trying to cope with the apparent destruction of a vast number of fundamental articles of faith.

One more knell remained to be struck, the most decisive of them all, and ringing out the remaining

tones to the hour of midnight. That knell was Einstein's discovery of the Law of Relativity. Many writers, basing their reasoning on a superficial understanding of his discovery, reached the conclusion that absolutes don't exist in moral and spiritual law, either. Truth, they declared, is whatever anyone wants it to be.

I mentioned earlier that I wrote a book years ago, *Crises in Modern Thought*. There I explained that values, although relative, are *directionally* so. Our understanding of human values, in other words, is actually liberated by the concept of relativity. It is in a position to grow endlessly toward perfection, now that it is no longer limited by absolutist concepts of right and wrong. Evolution, too, I wrote there, has only to be viewed afresh for Darwin's thesis to give deeper meaning to life. It hasn't snatched meaning away altogether. Again, Freud's investigations into the subconscious have opened the door to a vitally important discovery, one that is only recently beginning to be discussed: the *superconscious*.

There is no reason whatever to assume that, if things don't mean exactly what we thought, they must therefore mean nothing at all. Moral and spiritual realities are by no means lost to us. Darwin never actually robbed us of our dignity as human beings: He helped us, rather, by affirming our connection with all life, to see that human dignity is a state achieved only after hard evolutionary struggle, the ultimate goal of which is to reclaim our true dignity as souls.

Freud hasn't stripped us of the rationale for idealism: He has only shown the limitations of human nature, which prevent us from attaining those ideals.

And Einsteinian relativity never robbed us of universal values. It only undermined moral absolutism, which ultimately obstructs our development toward limitless wisdom.

The most important discovery of this age has been the fact that matter, far from being solid, is a vibration of energy. This realization is, increasingly, defining our understanding of reality. It is this discovery, above all, that convinces us we live in a New Age. The awareness that energy is the reality, and that the solidity of matter is transient, is changing our very view of the universe.

People are coming more and more to view life in terms of fluidity and change, including in this view their traditional beliefs, their institutions, their customs. Nothing seems chiseled in granite any longer. Welling up in human consciousness is a new sense of freedom. In the first exuberance of this spirit, many people have plunged headlong into the roiling eddies of sense indulgences. Hedonism however, in time, becomes tiresome. As we accustom ourselves to this New Age of Energy, people will regain their native equilibrium.

One unfortunate aspect of technology has been a universal increase in complexity. How many people, today, can keep abreast even of the information deemed essential to their own line of work? Specialization prevents people ever increasingly from studying anything outside their own particular fields of interest.

Human nature simply cannot continue in this direction indefinitely. The brain is not made to contain and process effectively an infinite amount of information. No matter how many facts we

"download" onto computer disks, there must come a time when all this outward focus of attention causes our nervous systems simply to break down and refuse to function. Many people already are dysfunctional, no doubt in reaction against the complexity we have created around us.

The future of mankind will, I am perfectly certain, include a return to simplicity. Art will not merely join the trend: It will actively help in bringing it about.

Art in future will become more interiorized, as people everywhere revert to a focus on life that is less technological, more people-oriented. Art once again will express human aspirations and ideals. It will abandon, no doubt with a sigh of relief, its fascination with techniques and artistic "isms." Social conflicts that drown perception of the individual in a formless sea of humanity will cease to claim the fervent support of artists.

The great historical themes of the past, and the grandiose sweep with which they were depicted, will, I believe, give way to a more intimate telling. The masses of humanity, so often depicted in those works, will be reduced to individuals, supported not by milling crowds but by their own relationship to truth, to God, and to the universe. These changes will appear naturally, as a result of the shift in people's attitudes toward life.

Symphony orchestras will, I think, become relics of the past. The impressive grandeur of symphonic music reached its peak already with Beethoven. To travel indefinitely down that road would require an increasingly fervent devotion to complexity, just

when human beings are beginning to long for a return to the simpler life, at their inner center.

Artistic emphasis will shift toward greater subtlety and sensitivity in self-expression. People will tire of the sensory overload brought on by so many instruments laboring together in a strenuous workout. The acclaim accorded to conductors for their skill at controlling large orchestras will subside, as people's admiration shifts to people who show skill at controlling themselves.

In keeping with an increasing love for personal freedom, small ensembles, such as quartets, trios, and duets, in which the instruments each get a turn at the melody line, will become increasingly the vogue.

The restlessness that is suggested by rapid 16th and 32nd notes, so common to classical music and so often necessary in piano music, for example, where volume fades away fairly quickly to silence, will be transformed by electronically produced notes, which can be sustained indefinitely.

Sampled music—notes, that is to say, that have been digitally recorded from live instruments—will turn out not to be the disaster so many musicians now dread. It will become possible, instead, for more musicians to play solo against studio-generated orchestras. Thus, musicians, instead of seeking posts for little pay in large orchestras—where much of the music selected offends their personal taste— and perhaps padding their income by teaching resentful little children or by performing in places that are demeaning to their talents, will be able to find audiences for music they produce inexpensively, and with greater personal satisfaction.

Composers, by the same token, will find it easier to get their works played, and to make a living by their art.

For music will come, in time, to be seen as a necessity of life, and not merely a form of entertainment. Indeed, people will understand the importance of all the arts to a healthy, harmonious, and happy existence. Art generally, therefore, and music in particular, will be supported financially by an appreciative public. I even foresee the day when musicians will be salaried by societies and individuals to perform regularly in town squares, parks, and other places frequented by the public for purposes of rest and relaxation.

Musical compositions will, I suspect, offer more latitude for interpretation, as society's prevailing mood shifts away from regimentation and control and toward greater freedom of self-expression. Musicians will begin to think of themselves as working in *cooperation* with composers, and therefore, in a sense, as co-composers. Music notation itself will become more skeletal, offered more as a suggestion to the musician than as an absolute directive.

Man's search for understanding will turn inward; it will plumb the depths of consciousness. Art, therefore, will become more personal; it will focus less on mass events, social reforms, and political struggles. People will lose faith in the ability of big government to solve their problems. They will become more independent in conscience, as freedom and individual responsibility become increasingly accepted as social norms. Art will mirror this direction of thought.

I doubt that chords in music will be abandoned, though they will no doubt reflect the general return to simplicity. Chords express a dependence on group thinking and interaction. This emphasis will diminish, I believe, as individuals increasingly assume responsibility for their own lives. As faith in higher values returns and is perceived as a personal, not an institutional, issue, greater importance will be given to melody.

Importance will be given also to the human voice, as the instrument par excellence for expressing human feelings and emotions. Electronic amplification will render it less necessary for singers to use their bodies as sounding boards to fill a concert hall. The operatic singing style—which makes it difficult sometimes to discern whether the singer is bellowing a war chant or crooning a love song—will be replaced by more sensitive voice production. Increasingly, indeed, the "sounding board" of the future will be, not the human body, but the "*chakra*s," or foci of spiritual energy in the body. Singers will learn to project feeling with their voices by infusing them with energy from the heart "*chakra.*" Peace and a feeling of expansion will be expressed in their voices by projecting the sound from the throat "*chakra.*" Joy and divine power will fill their tones when they direct them through the "spiritual eye" between the eyebrows.

As for painting, it will be expressed more, I suspect, in the form of light rays, and less through pigments on a canvas.

People will keep fewer paintings on their walls, and will devote more energy to enjoying each of them in turn. Indeed, in keeping with the new

175

emphasis on simplicity, there will be less of a tendency to surround oneself with a plethora of anything.

Again, the vibrations in a work of art will be considered its essential reality. Thus, people will no longer hang works on their walls that, even if well-executed, project vibrations they don't want in their lives.

Recently, I visited a metaphysical bookshop in Australia, where I was traveling on a lecture tour. The owners, a husband and wife, asked me if I would like to have my photograph taken by their "aura" camera. "Why not?" I replied. This sort of thing would have been ridiculed a few years ago. Today, however, it seems to be fairly widely accepted. The hues in my "aura" photograph were those I knew inwardly to be true.

Of special interest to me were other photographs the owners later showed me of themselves. The colors in these photographs, and the way they blended together, corresponded strikingly to what I sensed about their personalities. They were pleasant people; therefore the colors surrounding them were pleasant also.

The wife showed me two more "aura" photographs of herself. One of them had been taken after a physical healing; the other one, just before the healing. The contrast between these two was remarkable. It struck me how much more effectively these "aura" photos captured them than any normal photograph could have done.

Abstract expression in art is, I believe, here to stay. It will be more sensitive in future, however, appealing to people's inchoate feelings and soul-aspira-

tions, and will consist no longer of indiscriminate splurges of color that basically say nothing at all.

Impressionistic painting will be understood to have laid the groundwork for a more subjective, more thoughtful view of life. Art will abandon excessive realism as sterile and uninspired. Artists will attempt to suggest energy fields around things, and will place less emphasis on physical shapes. Matter will come to be considered a fleeting expression of ever-evolving spiritual realities.

Sculpture, inevitably, will become less heavy-handed, and will no longer hold up a symbolic mirror to a soul-less technocracy. It will suggest forms as mere veils for subtle energies and states of consciousness. Sculptors will strive to instill faith in people, and to deepen their insight into the meaning of life, instead of devoting their art to mockery. The forms they create, though solid, will suggest fluidity and grace. Sculptures of the future may combine crystalline shapes with plays of light, also—not in a spirit of whimsy, but as a serious effort to raise people's consciousness.

Architecture will be accepted as a fine art, for people will come to understand the need for bringing harmony to their environment. There will be a shift of emphasis from creating a personal space for oneself to the creation of an environment that everyone can enjoy. Because buildings are visible to everyone—unlike paintings, which can be seen only in homes and in museums—architecture will be given special importance among the arts. The concept of utilitarianism, though not rejected, will be expanded to include the utility to human existence of grace

and beauty. The primary emphasis in architecture will be on space, light, and harmony.

Color in architecture will be more important than in the past. It will be introduced with a view to blending harmoniously with Nature, even to the point of enhancing natural features that the eye might not have noticed otherwise.

Architects will come to understand that buildings have the potential for expressing human values, and should not be imposed on a community without regard for those values. They will find it necessary, before beginning their careers, to study religion, philosophy, and the other arts, that their structures be brought into line with the more sensitive development of human feeling.

Literature, finally, will cease to denigrate noble motives, justifying the practice as the "in" thing to do. The average writer will no longer pride himself on discerning base motives for high ideals. Writers will seek, rather, to inspire people to lofty thoughts and aspirations. Darwin and Freud, though not rejected, will be seen as having provided only rudimentary insights into the evolution of species and of individual human beings. Man's longing for self-perfection will be perceived, not as a distortion of his animal nature, but as being due to a deeper-than-conscious memory of his eternal reality. No longer will idealism be treated as a mere bubble in need of pricking by the needles of cynicism. Man's abiding reality will be seen to be, more than ever before, his higher Self.

People will be less concerned with humanity's "sinful" nature, inherited from Adam and Eve, and held up reproachfully as proof of our eternal guilt

before God. They will find it more and more natural to view their soul-nature, inherited from God, as their reality, however long-hidden by fogs of delusion.

Faith will grow out of intimate, personal experience, and will be less a blind affirmation of untested beliefs. Formal church services will increasingly be replaced by forms of worship that reflect this new faith. Religious art will contribute to this shift in values.

Choirs will be organized for the upliftment above all of the singers themselves, and will not focus on productions intended primarily to impress audiences. More common, in keeping with the spirit of simplicity, will be offerings of song and music by soloists, or by small singing and instrumental groups. There will be greater participation by congregations in singing *to* God, rather than singing *about* God. Gone will be the implied declaration to God, "Lo, *together* we worship Thee!" Implied, rather, will be the statement, "Beloved, we worship Thee in the hidden sanctuary of our own hearts."

God will no longer be thought of as only masculine. "He," the Heavenly Father and Imperial Lord, will be perceived also as "She," the tender and compassionate Divine Mother. For others, God will be thought of as Friend, or as the Infinite Beloved. God will be perceived above all as existing beyond form: as infinite wisdom, love, and joy.

Religious music will be not so much shouted in loud affirmation as it will be offered—murmured, even—in loving communion. Religious art, also, will be the artist's act of communion, and will incline, sensitively, toward understatement.

Melodies once again will be beautiful, as people achieve greater clarity in their faith. Paintings will satisfy, and will no longer deliberately threaten people's peace of mind in the name of "giving them art." Art everywhere will become more deeply meaningful, and will play a role in bringing humanity back to sanity once again, as artists strive to reawaken faith in people's hearts. Religious art will once more be at the forefront of artistic expression. Its themes, however, will no longer emphasize the differences between one religion and another, but will awaken in hearts everywhere a deeper awareness of universal truths.

Self-realization will be the major theme in artistic expression. Gone will be the former emphasis on articles of dogmatic faith.

These things I deeply believe. And I dedicate my poor efforts to bringing this world, though described here as belonging to the future, into present manifestation.

# About the Author

J. Donald Walters, 71, is a leading world authority on spirituality, meditation, and higher consciousness. He speaks nine languages, has written over 60 books, and composed over 300 songs. Says David Frawley, president of the American Vedic Institute, "J. Donald Walters, or Sri Kriyananda as he is also known, has been one of the most important exponents of yoga philosophy in the past 300 years. A close disciple of Paramhansa Yogananda (author of *Autobiography of a Yogi*), he went on to found Ananda, one of the largest and most successful groups of spiritual communities in the world. Walters has authored numerous books and tapes, and has composed and recorded elevating music. He is a kind of spiritual Renaissance man. There is little of human life and culture—from social to spiritual issues, to art, philosophy, and psychology, from the ancient past to the dawning future—that he has not examined insightfully. His work is marked by a certain refinement and sensitivity, a cultured approach that draws the reader gently into it."

Walters is author of *Superconsciousness—A Guide to Meditation* (Warner Books), *Meditation for Starters, The Art of Supportive Leadership, The Path, Cities of Light,* and many other titles. He is author of the bestselling *Secrets* series, and author of *Education for Life,* the book which launched the Education for Life Foundation, with schools in both the U.S. and abroad. His bestselling album, *Mystic Harp,* is a compilation of Celtic instrumental music performed by

Derek Bell, the legendary harpist of the five-time Grammy Award–winning group The Chieftains.

In 1968, he founded *The Expanding Light* meditation retreat in Northern California, one of the country's most successful retreats for meditation, spirituality, and alternative healing techniques. He also established Ananda Europa, a large guest retreat for meditation and yoga in Assisi, Italy. Today, there are seven Ananda communities throughout the world.

# Resources

*A Selection of Other Crystal Clarity Books*

**Superconsciousness—A Guide to Meditation**
by J. Donald Walters
trade paperback (Published by Warner Books)

Many books have been written about meditation. But this new book is something more. There is a power to this work that will give you an entirely new understanding of your potential—to expand your consciousness beyond anything you can now imagine, to the state of superconsciousness. This is not a book based on theory alone. The author writes with a simple, compelling authority, born of actual experience of the truths he presents. Glimpse into the heart and soul of someone who has spent nearly fifty years exploring the innermost reaches of human consciousness, and who has dedicated his life to helping others on the sacred journey to self-transcendence.

**Meditation for Starters**
by J. Donald Walters
book, cassette/CD (narration and music, 60 minutes)

This book gives both beginning and long-time meditators proven techniques and powerful visualizations for achieving inner peace. Written with simplicity and clarity, it also provides a way for readers to look at meditation as a "starting point" for everything they do. The companion audio is

available separately on both CD and cassette, or can be purchased as a set with the book.

## Secrets of Meditation
by J. Donald Walters
gift paperback, four-color

In *Secrets of Meditation* the author brilliantly encapsulates the essential keys to meditation with daily seed thoughts for each day of the month. Each affirmation is presented in a straightforward manner that allows you to repeat and remember it. It has been said we are what we eat. It would be truer to say, "We are what we think." For our minds express, and also influence, the reality of what we are far more than our bodies do. *Secrets of Meditation* is a potent guide to meditation, and points the way to the deeper levels of inner peace that we all so earnestly seek. Ideal for desktop use, *Secrets of Meditation* includes a striking design with four-color photographs that accompany each saying.

## The Path—
## One Man's Quest on the Only Path There Is
by J. Donald Walters (Swami Kriyananda)
trade paperback and hardcover

*The Path* is the moving story of Kriyananda's years with Paramhansa Yogananda, author of the spiritual classic *Autobiography of a Yogi*. *The Path* completes Yogananda's life story and includes more than 400 never-before-published stories about Yogananda, India's emissary to the West and the first yoga master to spend the greater part of his life in America.

## Autobiography of a Yogi
by Paramhansa Yogananda
trade paperback

One of the great spiritual classics of this century. This is a verbatim reprinting of the original, 1946, edition. Although subsequent reprintings, reflecting revisions made after the author's death in 1952, have sold over a million copies and have been translated into more than nineteen languages, the few thousand of the original have long since disappeared into the hands of collectors. Now the 1946 edition is again available, with all its inherent power, just as the great master of yoga first presented it.

## Do It NOW!
by J. Donald Walters
trade paperback

There is greatness within each one of us that lies waiting to be tapped, if only we knew how. J. Donald Walters' new book offers 365 fascinating and practical suggestions for deepening your awareness—of yourself, and of the world around you. Open the doorway to fresh creativity and a blossoming of your own highest potential. *Do It NOW!* is the distillation of a lifetime of creative endeavors.

## Money Magnetism—
### How to Attract What You Need When You Need It
by J. Donald Walters
trade paperback

This book has the power to change your life. It contains techniques and keys for attracting to yourself the

success that everyone seeks. It offers fresh, new insights on ways to increase your own money magnetism. This is a book about money, but also about a great deal more. Its larger purpose is to help you attract whatever you need in life, when you need it. Chapters include: What Is True Wealth?/You Are Part of an Intelligent Reality/How Much Wealth Is Available?/To Live Wisely, Give.

## The Art of Supportive Leadership
by J. Donald Walters
trade paperback and cassette

This practical guide is recommended for managers, parents, and anyone else who wishes to work more sensitively with others. Become an effective leader who gets the project done by involving and supporting the people working with you.

## Ananda Yoga for Higher Awareness
by J. Donald Walters (Swami Kriyananda)
trade paperback

This unique book teaches hatha yoga as it was originally intended: as a way to uplift your consciousness and aid your spiritual development. Kriyananda's inspiring affirmations and clearly written instructions show you how to attune yourself to the consciousness of the poses, so that each posture becomes a doorway to life-affirming attitudes, clarity of understanding, and an increasingly centered and uplifted awareness. Excellent for beginning and advanced students.

## *Audio Selections from Clarity Sound & Light*

### Autobiography of a Yogi
by Paramhansa Yogananda read by J. Donald Walters
(Swami Kriyananda)
audio book, selected chapters, 10 hours

Now, the original, unedited 1946 edition of *Autobiography of a Yogi* is available, with all its inherent power, in audio book form. Read by Swami Kriyananda, a close, direct disciple who lived and studied with Paramhansa Yogananda. Followers of many religious traditions have come to recognize *Autobiography of a Yogi* as a masterpiece of spiritual literature.

### Meditation for Starters
by J. Donald Walters
cassette/CD narration and music 60 minutes

Learn how to meditate, step by step, and discover a new world inside yourself. This recording begins with instruction in meditation. The simple, powerful, and clear explanation is an excellent refresher even for those who have been meditating for years. A guided meditation follows, taking you on a meditative journey to "The Land of Mystery," with beautiful music and soaring melodies. This is the companion audio for the book of the same name.

### Mantra
by Swami Kriyananda (J. Donald Walters)
cassette/CD, vocal chant, 70 minutes

For millennia, the Gayatri Mantra and the

Mahamrityunjaya Mantra have echoed down the banks of the holy river Ganges. Allow the beauty of these sacred sounds to penetrate every atom of your being, gently lifting you to a state of pure awareness. Chanted in Sanskrit by Kriyananda to a rich tamboura accompaniment. "Ancient, unhurried majesty." *NAPRA Review*

### Mantra of Eternity—AUM
by Swami Kriyananda (J. Donald Walters)
cassette/CD, vocal chant, 71 minutes

AUM is the vibration that underlies and sustains all of creation. Kriyananda chants AUM to the soothing accompaniment of tamboura. Chanting of Sanskrit mantras in India is often used for healing, calming the mind, and reducing stress.

### Himalayan Nights
by Agni and Lewis Howard
cassette/CD, instrumental, 60 minutes

Seamless sitar, tabla, and tamboura on one continuous track—a soothing tapestry of sound. Use *Himalayan Nights* as a relaxing musical background for any daily activity. ". . . will gently refresh and purify the spirit." *Music Design in Review*

### Raga Omar Khayyam—Himalayan Nights 2
performed by Agni and Lewis Howard
composed by J. Donald Walters (Swami Kriyananda)
cassette/CD, instrumental, 63 minutes

Inspired by Persia's classic love poem, this timeless music will take you on a wondrous carpet ride of

sound. The rhythm of the tabla weaving around the subtle sitar melody speaks to the soul, calms the mind, and uplifts the heart.

**The Mystic Harp**
by Derek Bell
cassette/CD instrumental 70 minutes

Derek Bell, of Ireland's five-time Grammy Award–winning *Chieftains*, captures the mystical quality of traditional Celtic music on this solo album of original melodies by J. Donald Walters. Derek plays Celtic harp on each of the nineteen richly orchestrated melodies, and is joined on the duet "New Dawn" by noted violinist Alasdair Fraser.

**I, Omar**
by J. Donald Walters
cassette/CD, instrumental, 61 minutes

If the soul could sing, here would be its voice. *I, Omar* is inspired by *The Rubaiyat of Omar Khayyam*. Its beautiful melody is taken up in turn by English horn, oboe, flute, harp, guitar, cello, violin, and strings. The reflective quality of this instrumental album makes it a perfect companion for quiet reading or other inward activities.

*For a free Crystal Clarity catalog*
*or for any additional information*
*please call: 1-800-424-1055.*